Ince

Published by the Getty Research Institute for the History of Art and the Humanities

Incendiary Art:
**The Representation of Fireworks
in Early Modern Europe**
Kevin Salatino

Bibliographies & Dossiers

The Collections of the Getty Research Institute for
the History of Art and the Humanities, 3

The Getty Research Institute Publications and Exhibitions Program

Bibliographies & Dossiers
The Collections of the Getty Research Institute for the History of Art and the Humanities
Julia Bloomfield, Harry F. Mallgrave, JoAnne C. Paradise, Thomas F. Reese, Salvatore Settis, *Editors*

Incendiary Art: The Representation of Fireworks in Early Modern Europe
Steven Lindberg, *Manuscript Editor*

This volume accompanies the exhibition *Incendiary Art: The Representation of Fireworks in Early Modern Europe,* held December 16, 1997, through March 1, 1998, at the Getty Research Institute for the History of Art and the Humanities.

Published by The Getty Research Institute for the History of Art and the Humanities,
Los Angeles, CA 90049-1688
© 1997 by The Getty Research Institute for the History of Art and the Humanities
All rights reserved. Published 1997
Printed in the United States of America

03 02 01 00 99 98 97 7 6 5 4 3 2 1

Unless otherwise indicated, all of the items illustrated are from the Department of
Special Collections, Getty Research Institute for the History of Art and the Humanities,
Los Angeles (abbreviated in the text as GRI).

Cover: Jean-Baptiste Thomas, draftsman, and François le Villain, lithographer, *La Girandola*
(detail). From: Jean-Baptiste Thomas, *Un an à Rome et dans ses environs* (Paris, 1823).
Frontispiece: Anonymous engraving of a fireworks naumachia. From: Jean Appier Hanzelet,
La pyrotechnie (Pont-à-Mousson, 1630). See fig. 31.

Library of Congress Cataloging-in-Publication Data
Salatino, Kevin.
Incendiary Art : the representation of fireworks in early modern Europe / Kevin Salatino.
p. cm. — (Bibliographies & dossiers: the collections of the Getty Research Institute for
the History of Art and the Humanities; 3)
Includes bibliographical references.
ISBN 0-89236-417-3 (pbk.)
1. Fireworks in art—Exhibitions. 2. Prints, European—Exhibitions. 3. Prints—17th century—
Europe—Exhibitions. 4. Prints—18th century—Europe—Exhibitions.
I. Getty Research Institute for the History of Art and the Humanities. II. Title. III. Series.
NE962.F57S25 1997
769'.49662' 107479494—DC21
 97-23613
 CIP

Contents

Foreword

The birthplace of fireworks is a historical conundrum that may never be resolved. General opinion favors China, though we know that the art of pyrotechny was also practiced in India from ancient times. Nor is it clear precisely when fireworks were introduced to Europe from Asia, only that this occurred sometime in the Middle Ages as a result of crusader contact or through returning European missionaries. Nevertheless, it appears that by the fourteenth century fireworks were already well established in Italy, fanning out from the Italian peninsula to the rest of Europe over the next two centuries.

Although textual documentation survives from the fourteenth and fifteenth centuries, it is only in the sixteenth century that consistent visual documentation of fireworks spectacles begins to be produced, a phenomenon that seems to parallel the evolving self-consciousness of European court life and culture. By the following century, pyrotechny (like court culture) had achieved an unprecedented splendor, variety, and sophistication. At the same time, the images commissioned to record them began more effectively to convey the refinement of the spectacles themselves, attaining by the eighteenth century a quality at times equal to some of the best art being made.

A number of these images have been assembled, arranged, and interpreted for *Incendiary Art: The Representation of Fireworks in Early Modern Europe.* The illustrated books, prints, manuscripts, drawings, and optical devices that appear in this exhibition and catalog are a small but representative selection from the Getty Research Institute's large and diverse collections of primary materials and fall into a subject area that has long been one of several areas of our collecting interest—the history of ritual, festival, and spectacle. It is through such exhibitions and publications that we hope to increase awareness of our collections in the scholarly community and the larger public.

I would like to thank Kevin Salatino, Collections Curator, Graphic Arts, who curated *Incendiary Art* and wrote its accompanying catalog, for the imagination and energy he has devoted to these projects. Using the surviving visual records not merely as documentary "points of origin" but as objects inherently worthy of study, he has approached this often overlooked material in fresh and innovative ways.

I would also like to thank the following institutions and their directors for providing objects that have greatly enhanced the quality of the catalog and exhibition: Dr. Olle Granath, Nationalmuseum, Stockholm, Sweden;

Dr. Dragon Klaick, Theater Instituut Nederland, Amsterdam, The Netherlands; Dr. Phyllis Lambert, Canadian Centre for Architecture, Montreal, Canada; and Dr. Thomas Weiss, Kulturstiftung Dessau-Wörlitz, Wörlitz, Germany.

—Salvatore Settis, Director
 Getty Research Institute for the History of Art and the Humanities

Acknowledgments

The eighteenth-century French engineer and theorist Amédée-François Frézier wrote that "a well-conceived and well-executed fireworks display cannot be the work of a single person." By the same token, a well-conceived and well-executed exhibition and catalog are not the work of an individual, but are, necessarily, collaborative enterprises. Among the "collaborators" I would like to thank are my readers—Salvatore Settis, Thomas F. Reese, and JoAnne C. Paradise—and my manuscript editor, Steven Lindberg; also, Julia Bloomfield; Louis Marchesano; Brian Parshall; Don Williamson and the staff of Visual Media Services of the Getty Research Institute: Jobe Benjamin, John Kiffe, and Robert Walker; Wim de Wit and the staff of Special Collections of the Getty Research Institute; Marcia Reed; Irene Lotspeich-Phillips; Mary Reinsch-Sackett; Deborah Derby; Barbara Anderson; Anne-Marie Schaaf; Katia Yudina; and the staff of the Getty Research Institute Library. Among those friends and colleagues outside the Institute to whom I am indebted are Anthony Apesos, Suzanne Boorsch, Deborah Krohn, John Moore, Natasha Seaman, Leo Steinberg, and Robert Williams.

Incendiary Art is dedicated to the memory of Michael Aprato (1958–1996).

> — Kevin Salatino, Collections Curator, Graphic Arts
> Getty Research Institute for the History of Art and the Humanities

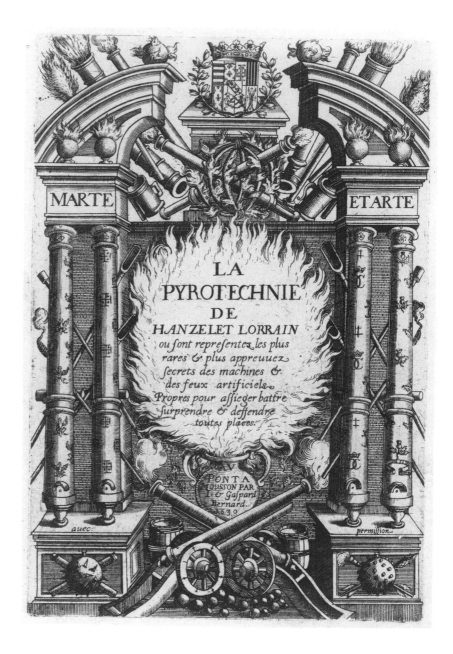

Fig. 1. Anonymous
Title page
Engraving. 9¼ × 6½ in (23.5 × 16.5 cm)
From: Appier Hanzelet, *Pyrotechnie* (1630)

Incendiary Art:
The Representation of Fireworks in Early Modern Europe

Kevin Salatino

They're very civilized, a friend who knows them as
well as they can be known had said to me of the
people in general, "plenty of fireworks and plenty
of talk—that's all they ever want."

—Henry James, *Italian Hours*

Part I. The Culture of Fireworks

Introduction

This exhibition does not endeavor to be a history of fireworks or to trace the
evolution of pyrotechnics as an art form. Nor does it strive to be a survey of
the early modern European court or civic spectacle. Its aim is both more lim-
ited and more inclusive. While it necessarily draws from the rich literature
and documentation of the European festival from the fifteenth to the eigh-
teenth centuries—celebrations of royal births and marriages, coronations,
peace treaties, and important state visits—it focuses on a small, if dramatic,
element of those complex and multilayered events by way of an abundant
store of surviving visual evidence in the form of prints, drawings, manu-
scripts, and illustrated books. It should be kept in mind, however, that the
fireworks that constituted the culminating moment or finale of a fete were
usually embedded in a much larger structure, and their meaning can only be
ascertained within that greater context.

"Recreational fireworks," pyrotechnics as a form purely of entertainment,
are to be distinguished from military fireworks, pyrotechnics adapted to the
uses of war. Perhaps the most potent emblem of this double role is found on
the title page of Appier Hanzelet's *La pyrotechnie* of 1630 (fig. 1), where the
rhyming Latin motto *Marte et Arte* (Of Mars and Art) announces the book's
twofold subject. While the focus of *Incendiary Art* is primarily on the *Ars*,
and only marginally on the *Mars*, of fireworks, the distinction is not always
so clear, particularly when a fireworks spectacle is so patently a form of war
as play, that is, where the martial and the ludic intersect.[1]

The politics of pyrotechnics is a theme running, threadlike, throughout
the exhibition. It is a critical commonplace that courtly festivities served
above all to exalt the principles of monarchy and dynasty, to demonstrate
power through expenditure, and to underline the fundamental distinction

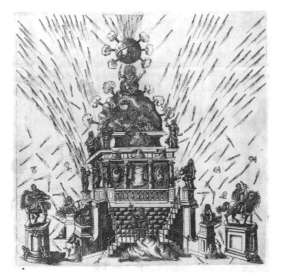

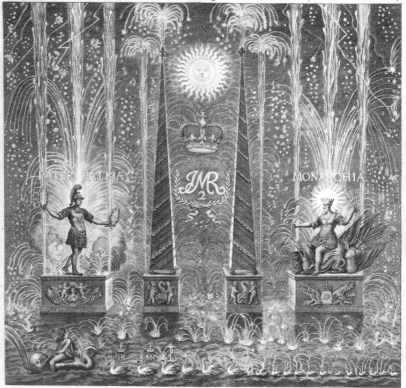

Fig. 2. F.M.R. [?], *etcher*
Fireworks machine in the shape of Mount Parnassus
Etching. 14¾ × 12⅝ in (37.5 × 32.0 cm)
From: Boscoli, *Applausi* (1658)

Fig. 3. Anonymous
A representation of the fire-works upon the river of Thames,
over against Whitehall, at their majesties coronation A°. 1685
Fireworks for the coronation of James II
[London: n.p., 1685?]
Engraving. 17⅜ × 20⅝ in (44.0 × 52.3 cm)
GRI, Brock Fireworks Collection, acc. no. P950001**·019

between the court and the rest of society. But the propaganda value of these costly, ephemeral entertainments rested less on the event than on its offspring, the record of the event. The illustrated fete books and prints produced and disseminated throughout Europe were a far more effective means of promoting influence and authority.

Nor can the unofficial written record be ignored. While laudatory official versions help to fill the inevitable gaps in the necessarily truncated visual accounts, contemporary journals or letters often point up the disparity between the actual occasion and its published description. Disasters, in a medium as volatile as fireworks, were common, and though state-sanctioned representations give no hint of this (for obvious political motives), the private accounts of those who were present frequently do. There are other reasons why such images routinely deviated from the truth, among them the practical reality that officially commissioned prints were often produced before the event took place, and that printmakers worked from drawings usually made by others and not always produced on site. As highly mediated objects, then, at least twice removed from the occasion they purport to record, these images should be approached cautiously.

A significant part of *Incendiary Art* is devoted to the subject of fireworks and the theory of the sublime as codified in the middle of the eighteenth century by Edmund Burke. *Incendiary Art* aims to demonstrate that fireworks in early modern Europe were invested with a plurality of meanings, not the least interesting of which was as a manifestation of the sublime in art and nature.

Above all, the exhibition attempts never to lose sight of the objects themselves. The items that have been assembled for *Incendiary Art* are, of course, cultural artifacts with a contextual meaning, subject to a great diversity of interpretations, but they are also entities with an independent aesthetic life. The exhibition and its accompanying catalog hope to draw attention to the extraordinary variety of formal "languages" invented by artists in their attempts to capture the fleeting, the momentary, the disintegrating, as well as to survey the multiple means by which the ostensibly nonnarrative and abstract phenomenon of fireworks was given a narrational structure. A few examples at the outset should prove illuminating.

Drawing Fire
The narrative and iconic strategies adopted by artists to illustrate fireworks constitute a kind of pictorial lexicon consisting of a highly heterogeneous vocabulary of idioms and dialects diverging morphologically according to time and place. The artist-printmaker, faced with the impossible task of rendering palpable the impalpable, of visualizing the "splendid confusion" (Burke) of a fireworks spectacle, often responded in interesting ways. A whole syntax, a visual taxonomy, of fireworks evolved out of these responses, from the extreme literalism of the mid-seventeenth-century *Applausi festivi fatti in Piacenza* (fig. 2)—all individually delineated rockets frozen, unexploded, in midflight—to the schematic, friezelike screen of subtly modulated dark and

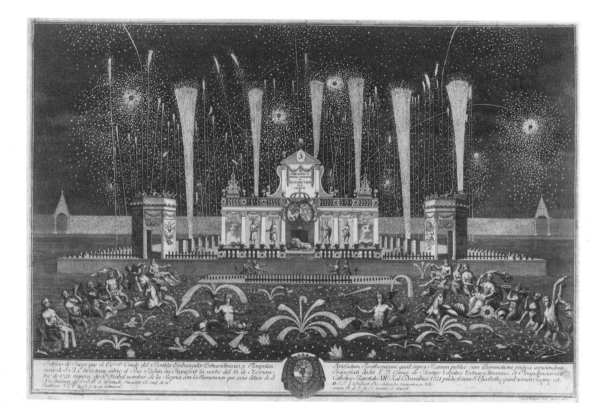

Fig. 4. Jakob Wangner (died 1781), *engraver*
Artificio de fuego que el ex.ᵐᵒ s.ᵒʳ conde del Montijo embaxador extraordinario, y plenipotenciario de S. M. E. hizo tirar sobre el rio Mehin en Francfort la noche del 18. de Noviembre de 1741...
Fireworks on the River Main, Frankfurt, 18 November 1741, in honor of Philip V of Spain
[Augsburg: n.p., 1741?]
Engraving. 18⅛ × 26⅜ in (46.0 × 67.0 cm)
GRI, Brock Fireworks Collection, acc. no. P950001**·035

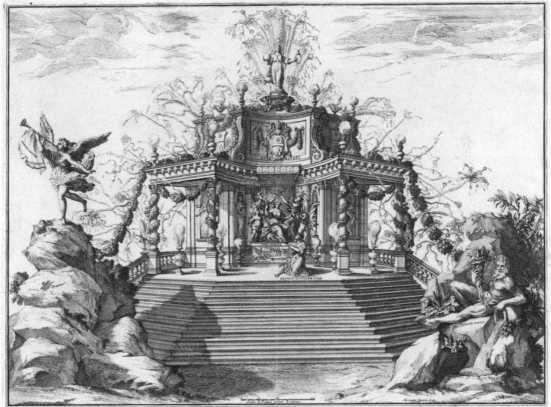

Fig. 5. Alessandro Specchi (1668–1729), *etcher*
La clemenza coronata dalla giustizia e dalla pace nel tempio dell'eternita: Machina di fuochi artifiziati fatta dalla città d'Urbino per solennizare l'esaltazione della santità di nostro signore Papa Clemente XI. al sommo pontificato
Fireworks machine erected in honor of Pope Clement XI, Urbino, ca. 1700
[Urbino: n.p., ca. 1700]
Etching. 17⅝ × 23⅜ in (44.8 × 59.3 cm)
GRI, acc. no. 970004**

5

Salatino

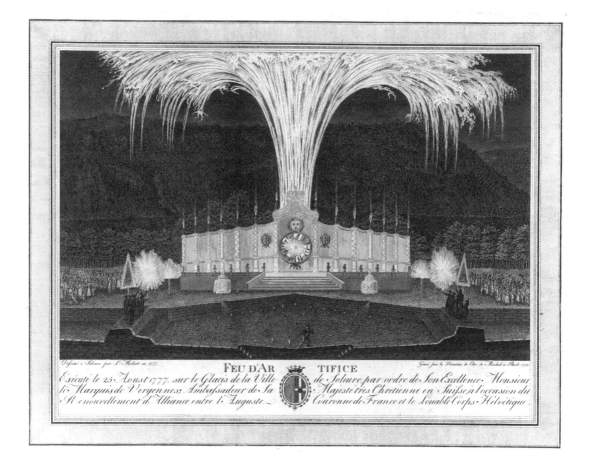

Fig. 6. Lorenz Ludwig Midart (1733–1800), *draftsman*
Christian von Mechel (1737–1817), *engraver?*
Feu d'artifice exécuté le 25 aoust 1777. sur le glacis de la ville de Soleure…à l'occasion du renouvellement d'alliance entre l'auguste couronne de France et le louable corps helvétique
Fireworks held on 25 August 1777 in Soleure, Switzerland, for the renewal of the alliance between France and Switzerland
Basel: Christian von Mechel, 1779
Engraving. 14⅛ × 17⅝ in (35.8 × 44.6 cm)
GRI, Brock Fireworks Collection, acc. no. P950001**·050

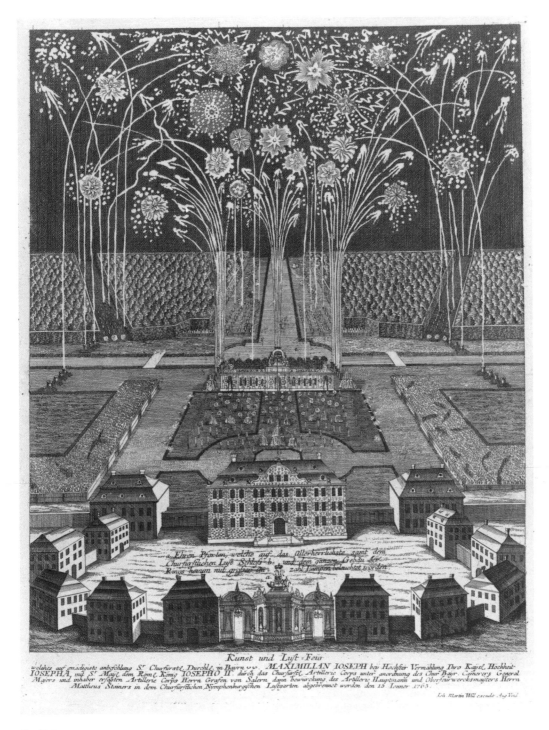

Fig. 7. Anonymous

Kunst und Lust-Feür welches auf gnädigiste Anbefehlung S.ʳ Churfürstl. Durchl. in Baijrn Maximilian Joseph beij Höchster Vermählung Ihro Kaijsl. Hochheit Josepha mit Sr. Maijl. dem Röml. König Josepho II...

Fireworks for the marriage of Joseph II, Nymphenburg, 15 January 1765

Augsburg: Johannes Martin Will, [1765?]

Engraving. 19½ × 14⅞ in (49.5 × 37.6 cm)

GRI, Brock Fireworks Collection, acc. no. P950001**·047

Salatino

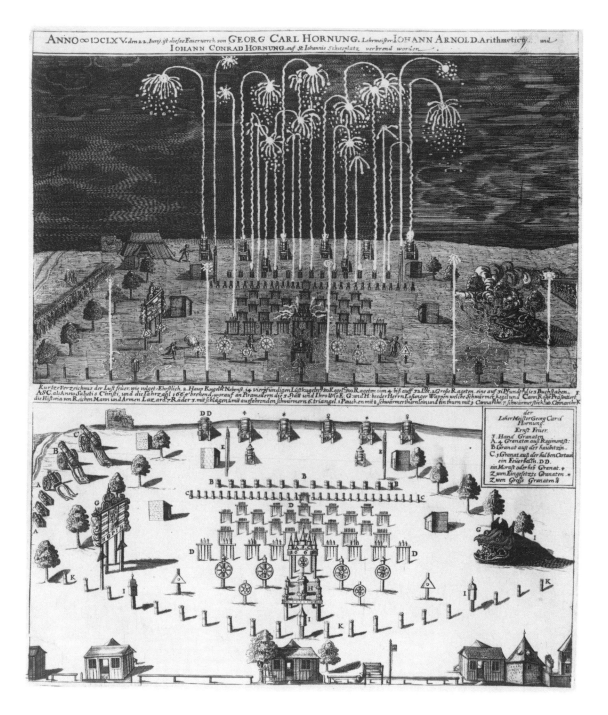

Fig. 8. Anonymous
Anno MDCLXV. den 22. Junij. ist dieses Feuerwerck von Georg Carl Hornung. Lehrmeister. Johann Arnold. Arithmetico. und
Johann Conrad Hornung. auf St Johannis Schiesplatz verbrend worden
Fireworks demonstration held at Nuremberg, 22 June 1665
[Nuremberg?: n.p., 1665]
Engraving. 14½ × 12 in (36.6 × 30.4 cm)
GRI, Brock Fireworks Collection, acc. no. P950001**·013

8

Fig. 9. Anonymous
Feu d'artifice et illuminations données à Versailles le 15 May 1774 lors du mariage de monseign.ʳ le comte de Provence
Fireworks and illuminations at Versailles, 15 May 1774, in honor of the marriage of the count of Provence (later
Louis XVIII) to Louise-Marie-Joseph de Savoie
Paris: Le Rouge, [ca. 1771]
Etching and engraving with yellow watercolor. 17½ × 29⅜ in (44.4 × 74.7 cm)
Collection Centre Canadien d'Architecture / Canadian Centre for Architecture, Montréal, Canada
Inv. no. DR1982:0105

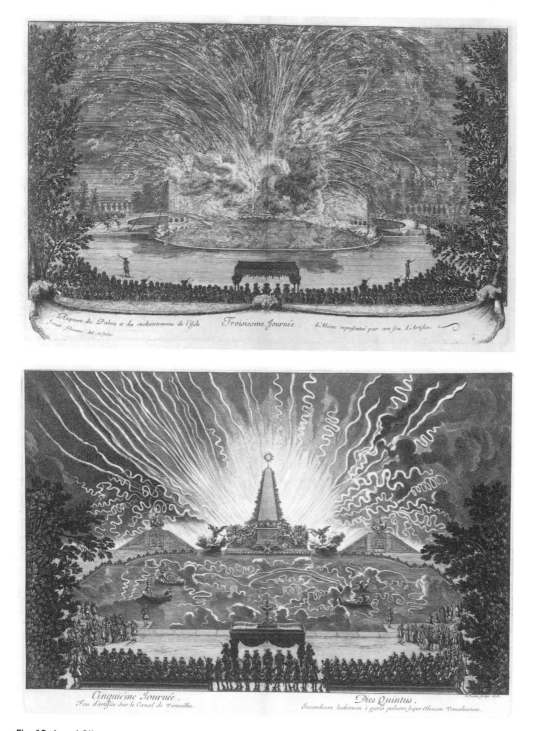

Fig. 10. Israel Silvestre (1621–1691),
draftsman and etcher
*Troisiesme journée: Rupture du palais et des enchantemens
de l'isle d'Alcine representée par un feu d'artifice*
Third day of "Les plaisirs de l'isle enchantée": Destruction
of the Palace of Alcine
Etching. 16⅜ × 18⅞ in (41.5 × 48.0 cm)
From: Félibien, *Plaisirs* (1674)

Fig. 11. Jean Le Pautre (1618–1682), *engraver*
Cinquiéme journée: Feu d'artifice sur le canal de Versailles
Fifth day of "Les divertissemens de Versailles": Fireworks
on the canal at Versailles
Engraving and etching. 16⅜ × 19¼ in (41.5 × 48.8 cm)
From: Félibien, *Divertissemens* (1676)

light tones, fire and water effortlessly merging, of the 1685 coronation fireworks for James II of England (fig. 3). The static, upright feather dusters that establish the nearly symmetrical grid of the print executed for the Frankfurt festival of 1741 honoring Philip V of Spain (fig. 4) stand erect like pyrotechnical sentinels, in pronounced contrast to, for example, the fireworks at Urbino, circa 1700 (fig. 5), that issue from their machine like hirsute spider legs, alive and organic, or sprout from it like some unruly, pullulating vine.

For the artist called upon to illustrate the *feu d'artifice* (fireworks spectacle) held at Soleure, Switzerland, in 1777 (fig. 6), the upper edge of the plate (the whole of which is emphatically demarcated by a trompe l'oeil decorative border) assumes a physical presence—the fireworks' geysering head strikes against it like a hose directed at a ceiling. While the Swiss artist sought to push beyond the two-dimensional limits of his space, the artist depicting the "Kunst und Lust-Feür" held at Nymphenburg, near Munich, in 1765, instead dramatically underscored the flatness of his surface (fig. 7). The star bursts, dandelion globes, and ragged serpents appearing in the sky above this toy Versailles look like some strange hieroglyphics cut into stone or metal. As a result, they are more assertively referential to their medium (copper) and technique (engraving) than most such representations.

Narrative responses were almost as varied as syntactical inventions. German prints of the seventeenth century, for example, frequently utilized a two-tiered approach, the foreground consisting of the fireworks "landscape" (the grounded matériel of the display), while the actual nighttime spectacle was projected onto the background as if on a movie screen (fig. 8). We find a very different approach to the problem of rendering time and sequence in the print issued for the several *feux d'artifice* given at Versailles for the marriage of the count of Provence to Louise-Marie-Joseph de Savoie in 1771 (fig. 9). Here, the artist diagrammatically condensed a diverse fireworks narrative of the "tableaux," "theater," and "aerial" sort into a series of static background screens behind a bird's-eye view of the palace and its grounds, thus merging the technical treatise with the festival print. More commonly, however, one paradigmatic moment was selected as representative, functioning as a visual synecdoche of the whole.

Pyrotechnics and Power
It should be remembered, however, that only rarely did these images exist in isolation. Neither Israel Silvestre's etching of the destruction by fireworks of the Palace of Alcine (fig. 10), an illustration of the third and last day of the fete "Les plaisirs de l'isle enchantée," held at Versailles in 1664, nor Jean Le Pautre's etching of the fireworks spectacle given on the fifth day of the "Divertissemens de Versailles" of 1674 (fig. 11), can be understood outside of the larger political, cultural, and narrational context in which they are embedded. Above all, Louis XIV's self-definition determined the structure and meaning of these highly complex theatrical events. The principle of order was manifested in the person of the king. As such, Louis's sun emblem not only

identified him with the god Apollo, in a post-Copernican universe it also placed him firmly at the center, around which everything (and everyone) revolved. The fabled world of Versailles, removed literally and figuratively from reality, became a vast, transformative stage that transcended, or at least reordered, time and space.

Silvestre's etching in particular is impossible to decipher without knowledge of the preceding, pre-fireworks, image (fig. 12), where we see the evil enchantress Alcine's palace (constructed on a tiny island at the center of the Basin of Apollo), flanked by two large receding walls of painted canvas functioning like the perspectival wings of a temporary stage. The fireworks that cause the destruction of the palace break Alcine's spell over Roger, the hero of Ariosto's *Orlando furioso* (the theme of "Les plaisirs de l'isle enchantée") and his knights (roles played by Louis and his court, respectively). But the illusion —the court as fictional chivalric characters—continued beyond the symbolic to the real, for Alcine's palace blocked the audience's view of the chateau of Versailles, the material seat of the king's power. With the enchantress's palace immolated, Versailles (the authentic site of enchantment), once again visible, reassumes its authority.

The fireworks are both revelation and apotheosis. The king, centered and elevated beneath a stately canopy, sits along a direct axis with the *chambre du roi* of the chateau. Since visual axes determined meaning at Versailles, which functioned as a grand outdoor theater, the importance of Louis's physical placement cannot be exaggerated. It defined his place, his courtiers' place, and, by extension, the position of the whole of society. The fireworks, which serve to restore order (the view of Versailles, the reestablished sight lines) through chaos (the confusion of rockets), are a powerful symbol of Louis's fundamental role as bringer of harmony in a world eternally subject to harmony's obverse.

The contrast between Silvestre's image and Le Pautre's is striking. Silvestre celebrates the chaotic moment, that instant before the smoke and flames clear to expose the palace destroyed and the Palace revealed. Le Pautre's fireworks, all spindly tendrils and uncoiling corkscrews, serve rather as backdrop to a rigidly centered obelisk, itself both the nucleus and the genesis of the pyrotechnics. The illuminated obelisk is a potent metaphor for Louis (as well as a symbol of his recent military victories), and the glowing fireball that crowns it is his personal device. André Félibien, author of the fete book in which Le Pautre's print appeared, wrote of the fireworks that "the entire decoration had a symbolic and mysterious meaning. In the obelisk and sun it was claimed that the king's glory was etched in the striking light, and solidly affirmed above that of his enemies."[2] The obelisk is axially aligned with Louis, who, as in the festival of 1664, is again aligned with the *chambre du roi*. Now, however, the spectacle turns away from the chateau and toward the distant prospect of the park of Versailles, as if acknowledging a larger sphere, though one still circumscribed by known perimeters. The increasing rigidity of Louis's court seems reflected in Le Pautre's harder, cleaner style, devoid of the "im-

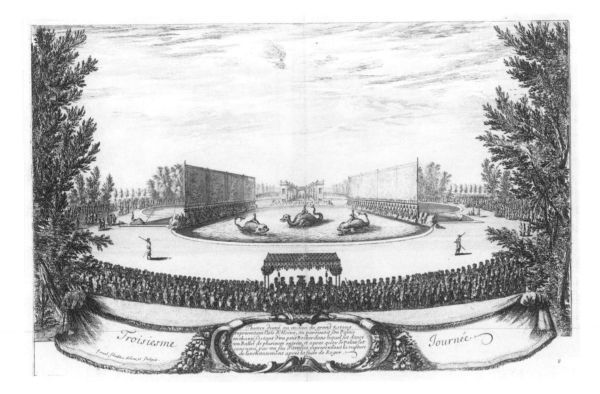

Fig. 12. Israel Silvestre (1621–1691), *draftsman and etcher*
Troisiesme journée: Theatre dressé au milieu du grand estang representant l'isle d'Alcine…
Third day of "Les plaisirs de l'isle enchantée": Palace of Alcine
Etching. 16⅜ × 19⅛ in (41.5 × 48.0 cm)
From: Félibien, *Plaisirs* (1674)

pressionistic" freedom of Silvestre's earlier approach made for, and emblematic of, a younger, more insouciant court, less world- and war-weary.

———————

Louis XIV's Versailles was a world set apart, both a microcosm of the universe and a place of enchantment wholly divorced from reality. While the three great fetes (of 1664, 1668, and 1674) held in the first ten years of his reign perfected the seventeenth-century court festival as political theater, they nevertheless emerged from a long tradition of such events throughout Europe. Many of the basic ingredients for the Versailles fetes are present in, for example, the marriage celebrations for the duke of Württemberg given at Stuttgart in 1609, and commemorated in Balthasar Küchler's *Repraesentatio der fürstlichen Auffzug und Ritterspil*. The 238 plates illustrating this remarkable festival book give an idea of the vast marshaling of intellectual, aesthetic, and economic resources, as well as the sheer labor, placed at the service of symbolic dynastic solidification, even in a duchy as small and politically dependant (as a fiefdom of the Holy Roman Empire) as Württemberg.

The foldout fireworks print (fig. 13) inserted at the front of the *Repraesentatio* stands alone as an independent moment with its own narrative, in contrast to the rest of the plates which follow a linear, sequential progression in order to suggest movement through time and space. The flaming fortress perched upon a miniature mountain located at the center of the fireworks engraving may be seen as a prototype for Louis XIV's Palace of Alcine and all its progeny forward to the great Paris fete of 1782 for the birth of the dauphin (see pl. 13) and, finally, to Napoleon's hubristic re-creation of Mount Saint Bernard of 1804 (see pl. 15). Yet the Württemberg structure is also descended from a tradition rooted in the origin of fireworks, that is, the art of war. The fortress thus gathers into itself the collective memory of war (here reduced to play), controlled by loftier forces. The seminude giant who stands before the castle, fire club in hand, merges the customary "wild man" (a convention of early pyrotechnical pageants) with the classical figure of Hercules. The tension of the image results from this melding of past (medieval) traditions and present (Renaissance and humanist) values. The latter is exemplified by the figures of Mars and Venus on classical columns flanking the fireworks machine, the theme, naturally, being war subdued by love, itself a learned reference to Virgil.

Unlike Sylvestre's or Le Pautre's prints for the fetes at Versailles, in Küchler's "world apart" the mundane keeps intruding. The spectators become unwilling participants in the drama, in contrast to Louis's scripted courtier-performers. Three of the foreground figures, for example, turn away from the fireworks, covering their faces protectively, while another in the crowd dashes to escape a rocket. This intrusion of the commonplace and the momentary, this messiness and contingency, is forbidden in the rarefied world of Versailles, defined by restraint and order, its serried ranks of placid spectators gazing with aplomb at nature's fury pacified by the imperturbable Sun King.

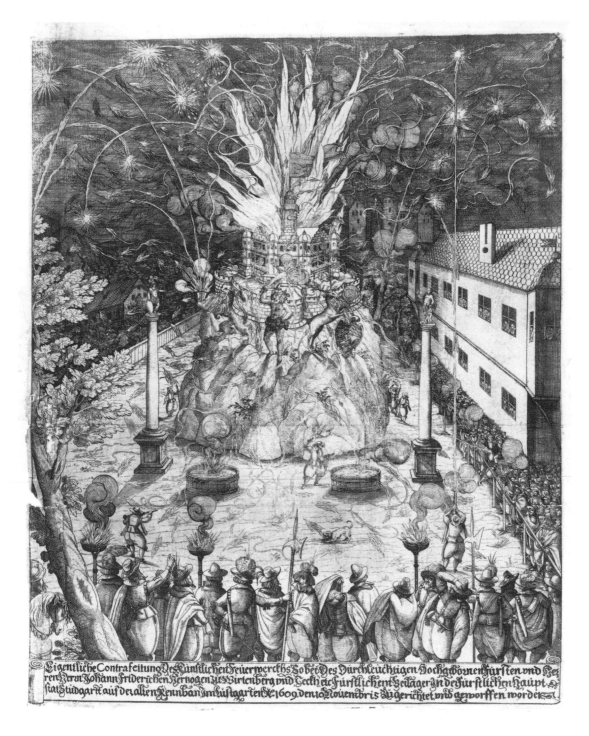

Fig. 13. [Balthasar Küchler (ca. 1571–1640), *engraver?*]
Eigentliche Contrafeitung des Künstlichen Feuerwerckhs so bei des... Johann Friderichen Hertzogen zu Wirtenberg
und Teckh etc Fürstlichem Beilager in der Fürstlichen Haupt Stat Studgartt... A.º 1609. den 10 Novembris zugerichtet
und geworffen worden
Fireworks in Stuttgart, 10 November 1609, for the marriage of Johann Friedrich, duke of Württemberg, to Barbara
Sophie, margravine of Brandenburg
Engraving. 14⅞ × 11⅝ in (37.7 × 29.5 cm)
From: Küchler, *Repraesentatio* (1611)

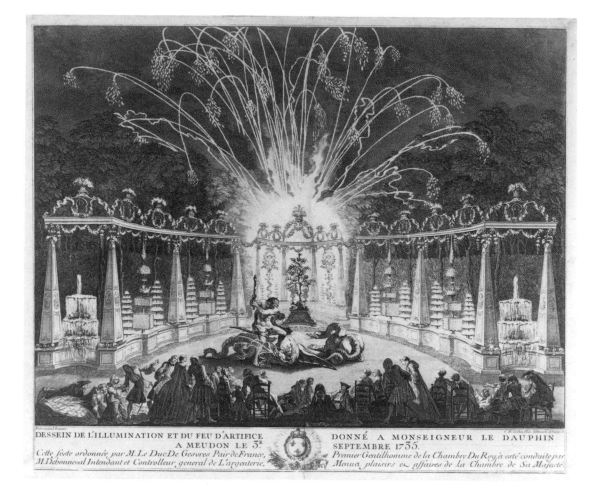

Fig. 14. Charles-Nicolas Cochin le fils (1715–1790), *draftsman and etcher*
Dessein de l'illumination et du feu d'artifice donné a monseigneur le dauphin à Meudon le 3ᵉ septembre 1735
Fireworks and illuminations for the birthday of the dauphin
[Meudon?: n.p., 1735?]
Etching and engraving. 16¼ × 19½ in (41.5 × 49.5 cm)
GRI, Brock Fireworks Collection, acc. no. P950001**-028

Perhaps the closest "Versailles" came to the informality of Stuttgart was not at Versailles at all, but at Meudon, in 1735, at the dauphin's sixth-birthday celebrations (fig. 14). There, against an ephemeral backdrop consisting of a semicircular colonnade with tinsel fountains and stacked, flaming structures resembling a pyrotechnical banquet, Hercules' twelfth labor plays itself out. With familiar fire club raised, the hero slays the dragon guarding Hera's golden apples in the mythical garden of the Hesperides. Unlike Louis XIV's courtiers, the Meudon party is carelessly, haphazardly dispersed, either seated casually on chairs or strewn across the ground engaged in conversation. It is not immediately clear where the young dauphin is; he is not, at any rate, at the center of a universe of revolving planets. The artist, Charles-Nicolas Cochin le fils, successfully conveys a sense of the ennui, the easy sophistication of a court accustomed to such *divertissements*.

At Stuttgart there existed an implicit tension, a creative dialogue, between the old and the new. At Meudon, however, what was fresh and original at the court of Württemberg has devolved into a stale language of meaningless classical motifs created for the amusement of a child, Sun King or no. The rhetoric of Louis's Versailles survives, of course, at Meudon. Not visible in the print was an inscription, on a central panel behind the tree bearing the golden apples, that read "a single ray of my sun eclipses all others." Invisible too is the larger context of the drama—the violence of Hercules' battle with the dragon, his victory, the fruit plucked and offered to the dauphin, and the "shepherds" dance that concluded the entertainment. Intentionally or not, Cochin underscored the "domesticity" and dissolution of absolutism accomplished at Meudon.

The atmosphere of domesticity we find at Meudon stands in marked contrast to the spirit of the "Hercules Fireworks" held on the walls of the castle of Dresden in 1678 (fig. 15), concluding a month of festivities honoring the elector of Saxony, Johann Georg II. A giant mouth of hell was the principal fireworks structure, from which there emerged battling figures watched over by the three-headed hound, Cerberus, as can be seen at the far left of the print.[3] To the right, three monumental pyrotechnical sculptures of the furies—bearing hatred, envy, and war—do battle with a fourth, Hercules, identified by his attribute, the club. Most of the image is dedicated, however, to the fireworks themselves, richly delineated in repeated vertical slashes against the night sky, punctuated by three tremendous sprays feathering out from the rocky structure enclosing the entrance to hell. While at Meudon Hercules' traditional "Christianized" resonance (vanquisher of enemies, slayer of heretics) is muted, a distant echo of its former self, at Dresden the ideological force of the metaphor still retains some of its potency, an energy conveyed by the representation of the spectacle. There is no domesticity here; the foreground shows no spectators, only a vertiginous descent into the castle courtyard.

Salatino

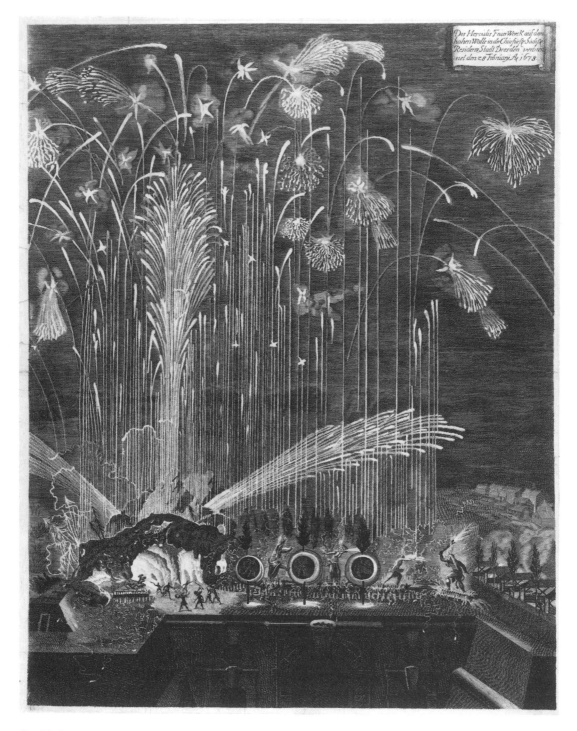

Fig. 15. Anonymous
Des Herculis FeuerWerck auf dem hohen Walle in der Churfürstl. Sächs. ResidenzStadt Dresden verbrennet den 28 Februarij A. 1678
"Hercules Fireworks" at Dresden, 28 February 1678, in honor of the elector of Saxony, Johann Georg II
[Dresden?: n.p., 1678?]
Engraving. 21¼ × 16½ in (54.0 × 41.9 cm)
GRI, Brock Fireworks Collection, acc. no. P950001**-017

18

Reception / Deception

The organizers of recondite fetes like those at Versailles, Meudon, or Dresden either presupposed an audience sufficiently well educated to understand their often hermetic allegories or were prepared to explain them through a printed program. After describing the narrative conclusion of a fireworks spectacle held at Vaux-le-Vicomte in 1661 — an obscure mythological pantomime involving nereids and Neptune and naiads — Jean de La Fontaine confessed, with his usual sense of whimsical irony, that he "didn't see any of this, but it doesn't matter: / To tell it in this way / Is always good; and as for you, / Don't make it a point of faith."[4] He meant that, as he watched the narrative, the strange goings-on of gods and fabled creatures were not at all clear, not, that is, without the program usually distributed at or before these events. The confusion that characterized such occasions — the thousands of bursting rockets, the accompanying drums and trumpets and cannon blasts — can even invade the language used to describe them. "Suddenly we saw the sky darkened by a dreadful cloud of rockets and serpents," La Fontaine reported, immediately wondering "should one say 'darkened' or 'illuminated'?"

In the sumptuous published account of the festival held in Rome in 1637 to celebrate the election of Ferdinand III as Holy Roman Emperor (*Applausi festivi fatti in Roma per l'elezzione di Ferdinando III*), the author, Luigi Manzini, informs us that, since His Highness foresaw that the public would have great difficulty comprehending the highly subtle allegory unfolding in a series of transformations of the fireworks structure (the *macchina*, or "machine"), "he desired that each night programs be distributed, the contents of which would reveal to the eyes the artifice and the aim of the *macchina* there proposed."[5]

By the middle of the eighteenth century the desire to clarify the complexities of a fireworks performance for its audience had become a requirement. In Amédée-François Frézier's *Traité des feux d'artifice pour le spectacle,* a work that codified and theorized two centuries of recreational firework-making, we learn that:

> One must take pains to instruct by means of printed explanations distributed to the public. This common precaution is so necessary that without it the wit that one employs is a waste of time for the majority of the spectators.[6]

While printed explanations of the sort Frézier described grant us access to a festival's programmatic intentionality, our knowledge of the reception of these spectacles (how they were perceived by contemporaries, for example) is based primarily on official published descriptions. These are seldom other than laudatory. From private journals and letters, however, we hear, from time to time, dissenting voices.

Of the Paris fireworks of 1763, Papillon de La Ferté, superintendent of the "Menus-plaisirs," complained in his journal that they were a failure, the city not having taken the precautions he had urged in view of the excessive

humidity caused by the recent rains.[7] And both Papillon de La Ferté in his journal and Madame du Deffand in a letter to Horace Walpole expressed their disappointment with the fireworks at Versailles for the marriage of the future Louis XVI to Marie-Antoinette in May, 1770, a spectacle again adversely affected by storms and the excessive smoke that resulted, thus "prevent[ing] one from seeing the whole effect."[8] Similarly, the plainspoken duc de Cröy's description of the extravagant *feu d'artifice* that terminated the Paris celebrations of 1782 for the birth of the dauphin (the son of Louis XVI and Marie-Antoinette) stands in stark contrast to both the official accounts and the officially sanctioned visual records:

> In the gallery I met M. Moreau, architect of the city, whom I praised for that which was well done but criticized for the too massive decoration of the fireworks machine, for being too close, as well as for not being decorated on all four sides and for having too thick a framework. The pyrotechnists had no room and did not dare to light or sustain the fireworks, which were a complete failure.[9]

Papillon de La Ferté was obliged, given his position, to concern himself with the often unpleasant realities of ephemeral entertainments, chief among these being their frequently excessive cost. In a particularly revealing journal entry, he described his proposal for a greatly reduced fireworks spectacle for the Versailles wedding festivities of 1770, which would "permit us to spend more for those things that are perhaps more agreeable to the king and the public than a fireworks display, the success of which is very uncertain."[10] In the end, Papillon's hand-wringing, remonstrating, and economizing came to naught, since Monsieur Torré, the pyrotechnist (pl. 14), "abusing the trust of the duc d'Aumont, who has given in to all his demands, finds himself to have greatly exceeded the expense of his part," which put Papillon "in a real affliction to the point of being sick."[11] One can understand his reaction in light of the ruinous condition of the royal treasury by the end of Louis XV's reign. The need to curtail expenses runs through Papillon's journal like a mournful refrain.

The London celebrations in 1749 for the Peace of Aix-la-Chapelle (signaling the conclusion of the War of the Austrian Succession) included a very ambitious pyrotechnical display, its fabulously expensive machine the work of the Italian architect and fireworks master Giovanni Niccolò Servandoni, who was imported to London to oversee the event. The several prints issued to commemorate the fireworks, held in London's Green Park, do not correspond to Horace Walpole's eyewitness testimony. The spectacle, he wrote:

> by no means answered the expense, the length of preparation [nearly six months], and the expectation that had been raised.... The rockets and whatever was thrown up into the air succeeded mighty well, but the wheels and all that was to compose the principal part, were pitiful and ill-conducted, with no change of coloured fires and shapes: the illumination was mean, and lighted so slowly that scarce anybody

had patience to wait for the finishing; and then what contributed to the awkward-
ness of the whole, was the right pavilion catching fire, and being burned down in
the middle of the show.... Very little mischief was done, and but two persons were
killed: at Paris there were forty killed, and near three hundred wounded, by a dis-
pute between the French and Italians in the management, who quarreling for prece-
dence in lighting the fires, both lighted at once and blew up the whole.[12]

While the images produced (figure 16, for example) betray a certain stiff-
ness of execution (perhaps the result of having been made before the event),
they nevertheless depict a successful conclusion, particularly "the wheels and
all that was to compose the principal part," which Walpole reveals in fact to
have been "pitiful and ill-conducted." In the end, as the king and printmakers
knew, the occasion was less important than its published record, which would
be disseminated to an audience infinitely larger than that which saw it mis-
fire. These paper messengers were far more effective engines of political pro-
paganda than the festivals they mirrored.

The revelations of a Walpole or a Papillon de La Ferté are, however, rela-
tively rare. More frequently, the surviving records emphasize their inability
sufficiently to describe the marvels of these elaborate enterprises — a complex
collaboration between architects, painters, sculptors, engineers, skilled crafts-
men, pyrotechnists, musicians, and armies of workmen. And the visual records
are, inevitably, no more than pale reflections of their subjects.

The difficulty in attempting to convey the effect of these entertainments,
which often united music, dance, theater, jousting, feasting, illuminations, and
fireworks in a highly textured and nuanced ensemble, is expressed by André
Félibien, who concluded the *Relation de la feste de Versailles* (his account of
Louis XIV's fete of 1668) by confessing that:

> Any picture I have endeavored to make of this beautiful festival . . . is very imper-
> fect, and you must not believe that the idea you form based on what I have written
> in any way approaches the truth. You see here pictures of the principal decorations,
> but neither words nor images are able adequately to represent all that served to
> give pleasure on this great day of rejoicing.[13]

In a similar vein, the author of the opera-ballet *Ercole in Tebe* (Hercules in
Thebes; Florence, 1661), acknowledged that "the engraved figures depicting
the stage sets, resemble them little or not at all,"[14] and he promised images
that would more accurately reflect the beauty of the originals, a promise never
fulfilled, nor probably intended to be.

Composition, Narrative, Privilege, and Production

The *feu d'artifice* held in Paris on the Seine in observance of the birth of the
dauphin in 1730 provides a particularly good case study of the visual record
as pale reflection of the event it is meant to depict. It also embodied the
principles held to be essential to a successful fireworks display. In his entry

A Perspective View of the Building for the Fireworks in the Green Park, taken from the Reservoir.

Printed according to Act of Parliament & Sold by T.Brooks facing Southampton Street in the Strand, & R.Sayer opposite Fetter Lane Fleet Street.

PLAN ET VUE DU FEU D'ARTIFICE

Tiré a Paris sur la Riviere le 21 Janvier 1730. Entre le Louvre et l'Hôtel de Bouillon, au Suiet de la Naissance de MONSEIGNEUR LE DAUPHIN, par ordre de LEURS MAJESTEZ CATHOLIQUES. Et par les Soins de leurs Excellences M. le Marquis de Santa Cruz, et M. de Barrenechea Ambassadeurs Extraordinaires et Plenipotentiaires d'Espagne

Fig. 16. P. Brookes (active 18th century), *draftsman*
Paul Angier (active mid-18th century), *engraver*
A perspective view of the building for the fireworks in the Green Park, taken from the reservoir
Fireworks in London, 27 April 1749, in celebration of the Peace of Aix-la-Chapelle
[London]: P. Brookes, [1749?]
Engraving. 14⅞ × 21⅝ in (37.8 × 55.0 cm)
GRI, ID no. 89-F4

Fig. 17. Giovanni Niccolò Servandoni (1695–1766), *draftsman*
Dumont le Romain (1701–1781), *etcher*
Plan et vue du feu d'artifice tiré a Paris sur la riviere le 21 Janvier 1730...
Fireworks on the River Seine, Paris, 21 January 1730, for the birth of the dauphin
[Paris: n.p., 1730]
Etching. 12¾ × 19⅜ in (32.3 × 49.2 cm)
GRI, Brock Fireworks Collection, acc. no. P950001**-027

for "Fireworks" (*Feux d'artifice*) in Diderot's *Encyclopédie,* the playwright Jean-Louis de Cahuzac drew special attention to this fete ("more beautiful than any that had ever been given") as manifesting the "highest principles for the composition" of a fireworks display. The pyrotechnist must, Cahuzac insisted:

> always have before his eyes, while forming his plan for the different fireworks that will make up his composition, not only questions of coordination ... but, even more, he must combine all the parts into the general outline of the spectacle designated by the decoration. ... It is in the nature of things that all spectacles represent something. Now, when we paint objects without action we represent nothing. ... The movement of the most brilliant rocket, if it does not have a fixed aim, displays nothing but a trail of fire that vanishes into thin air.

"Those fireworks," Cahuzac continued:

> that only represent a kind of repetition through the play of different colors, movements, and brilliant effects ..., no matter how cleverly designed, will never amount to anything more than the frivolous charms of paper cutouts. In all the Arts it is necessary to paint. In the one that we call *Spectacle,* it is necessary to paint with actions.[15]

For Cahuzac, the birthday celebrations of 1730 successfully accomplished the compositional and narrational principles set out in his *Encyclopédie* entry.[16] Dumont's engraving of Giovanni Niccolò Servandoni's magnificent machine (fig. 17), however, gives only the barest idea of a spectacle in which "grandeur, variety, and magnificence reigned equally," "nature was defeated," and "all the obstacles of the season [winter] surmounted," according to the reporter for the *Mercure de France.* "It is easier to imagine than to describe," he confessed, "and we are forced to agree.[17]

In three extraordinary acts, the space between the Pont Neuf and the Pont Royal was transformed into a monumental public theater, the focus of which was two mountains eighty feet high (called "volcanoes" in the texts), representing the Pyrenees, which separate France from Spain (the spectacle was ordered by Philip V of Spain, the French grandson of Louis XIV). From between the mountains a sun rose, signifying the birth of the Sun King, while above, a rainbow forty feet in diameter appeared suddenly, bridging the two summits and supporting the goddess Iris. The illuminations and all the rich variety of fireworks that characterized the fete have been ignored by the engraver, Dumont, in order to focus on the allegorical set piece — the spectacle's climax. Essentially, one moment is captured and frozen, the longer narrative (the combat of marine monsters, the rain of fireworks from the summit and crevices of the mountains, the pyrotechnical display shot from tower to tower) eliminated. What results, of course, is a rather tepid visual record, unlikely to impress without the meticulous textual descriptions.

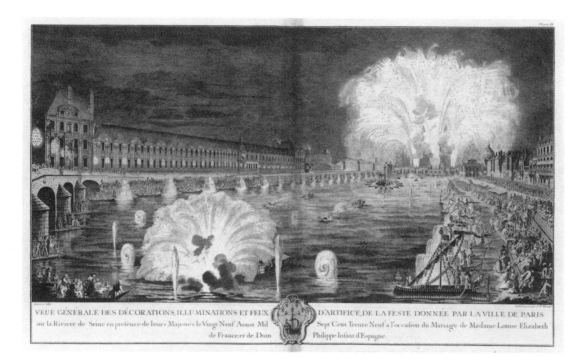

Fig. 18. Jacques François Blondel (1705–1774), *draftsman and engraver*

Veue générale des décorations, illuminations et feux d'artifice, de la feste donnée par la ville de Paris sur la riviere de Seine en presence de leurs majestés le vingt neuf aoust mil sept cent trente neuf a l'occasion du mariage de Madame Louise Elizabeth de France et de Dom Philippe Infant d'Espagne

Fireworks on the River Seine, Paris, 29 August 1739, for the marriage of Madame Louise Elizabeth and Don Felipe of Spain

Engraving. 24½ × 34¾ in (62.1 × 88.4 cm)

From: *Description des festes données* (1740)

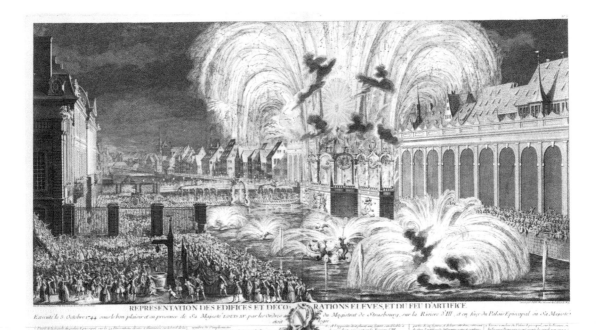

Fig. 19. Johann Martin Weis (1711–1751), *draftsman*
Jacques-Philippe Lebas (1707–1783), *engraver*
Representation des edifices et decorations elevés, et du feu d'artifice exécuté le 5. octobre 1744 sous le bon plaisir de sa
majesté Louis XV par les ordres du magistrat de Strasbourg...
Fireworks held in Strasbourg, 5 October 1744, for the convalescence of Louis XV
Engraving. 24⅝ × 35½ in (62.5 × 92.0 cm)
From: Weis, *Représentation* (1745)

The festival marking the marriage nine years later of Madame Louise-Elizabeth (eldest daughter of Louis XV) to Don Felipe (infante of Spain), while certainly imposing, was no more so than the celebrations for the dauphin in 1730. The difference lay, instead, in the record bequeathed to posterity. For the wedding festivities of 1739 a magnificent fete book was produced (*Description des festes données par la ville de Paris à l'occasion du mariage de Madame Louise-Elizabeth;* Paris, 1739), mirroring in its size (24⅜ × 18⅝ in) the magnitude, extravagance, and ostentation of the festival itself. The most impressive illustration, Jacques-François Blondel's massive double plate of the *feu d'artifice* (held, as in 1730, between the Pont Neuf and Pont Royal), successfully conflated the whole complex narrative into a coherent compositional whole (fig. 18).

The fireworks display, which was divided into twelve parts and conducted with "magical" precision, included illuminations (sixty barques hung with lanterns *à la chinoise* lining each bank from bridge to bridge), three-tiered fire fountains emerging from the river's surface, several species of water fireworks, a battle of marine monsters, a musicians' pavilion in the center of the Seine, a Temple of Hymen with a giant sun, and a finale consisting of one large and two small girandoles. Blondel sacrificed the sequential order of these "acts" in order to suggest a greater unity and integrity. The print is intended, above all, to impress, both by its physical size and by its conflation of pyrotechnical elements—astounding by quantity. Only in this way was the artist able to suggest the splendid controlled chaos (the triumph of art over nature) of the actual spectacle—the cacophony of mingled noises, explosions of cannons and rockets, discordance of drums and strings and tympani, so many brilliant lights flaring and fading, fire doing battle with water.

The unusually massive dimensions of the book in which Blondel's print appears make it decidedly unwieldy. It is itself a kind of monument, granting the ephemeral a certain permanence. Its sequential nature allows the reader-spectator to experience the event in time, while its architectonic quality (the great space it occupies, which one is obliged to walk around) simulates and perpetuates the spatial and architectural elements of the actual fete. By choosing a distant perspective for the firework print, Blondel emphasized the spectacle while deemphasizing the thousands of spectators—a seething, anonymous mass, virtually democratized by the magnitude of the thing they are witnessing, an astonished crowd consisting "of all social levels, all ages, and all sexes," as the *Mercure de France* reported.[18]

The engraver of the splendid plate illustrating the *feu d'artifice* held at Strasbourg in 1744 for the convalescence of Louis XV (fig. 19) clearly knew Blondel's print and, though constrained by what was obviously a cramped and incommodious site, managed nevertheless to convey a sense of grandeur. Most of the elements we have seen in the fete of 1739 are present here; the artist (Jacques-Philippe Lebas) even repeats the syntax of Blondel's fireworks, great scalloped umbrellas against which tiny smoke clouds appear in silhouette.

No longer merely illustrational, Blondel's and Lebas's prints are able aesthetically to stand on their own ("liberated" from the texts into which they have been bound), having successfully absorbed the compositional, narrational, and thematic principles of Renaissance and Baroque art theory. Blondel executed his "documentary" print as if he were rendering an important historical event (a *storia*, to use Leon Battista Alberti's famous expression), as, in fact, he was, and he marshaled all his skill as formidable draftsman and architect to realize his image. Although the products of these ephemeral enterprises no longer exist, except in prints like Blondel's, their political and cultural significance in their historical moment cannot be overstated. As a reflection of a monarch's wealth and prestige, as a sign of his ability to raise vast forces quickly and efficiently (like an army), these costly events and the propaganda commissioned to perpetuate them were an essential form of early modern statecraft. Through an elaborate mechanism of serious play, then, they mirrored a larger order: art as an instrument of power.

A volume as rich and costly, not to mention ungainly, as the *Description des festes données par la ville de Paris* was intended not to be purchased but rather to be presented ceremoniously to persons of rank, a diplomatic gift signifying the status of the recipient. The very high level of production (the quality of the paper and printing, for example) should be seen in this politico-presentational context. The three Russian etchings printed on satin that narrate the four-act fireworks drama presented before Catherine the Great in 1775 (pl. 3), should be seen in the same light as the *Description*. Presumably intended for presentation to a foreign head of state or important official representative, they are particularly good examples of the luxury status such objects held, as well as the codified distributional hierarchy based on medium (paper vs. satin) of these and other similar festival prints.[19]

We should similarly approach an impressive object like the engraving documenting the fireworks spectacle held at Nuremberg in 1717 to celebrate the capture of Belgrade from the Ottoman Turks by Emperor Charles VI, magnificently printed in flame-red ink (pl. 4). As the image survives also in black-ink examples, and as printing on this scale in colored inks was relatively rare at this early date, there is no doubt as to the special status that the sanguine impression must have held. Certainly, the red ink is appropriate to its subject; it suggests the substance of fireworks, even if fireworks themselves usually appear white against a black sky. The red coloring, then, is primarily allusive (in conjuring up the idea, rather than the reality, of fire) and privileging (in the status it acknowledges in its recipient). Unfortunately, we do not know for whom this print was intended. Nor do we know how many impressions in red were struck. Nor do we know how it was used. Unlike today, such "documentary" prints were not ordinarily framed and displayed. Frequently, they were bound between covers with similar material, textual and visual. When preserved intact, these albums, often compiled by collectors, can tell us a great

Salatino

Fig. 20. Francesco Gradizzi (1729–1793), *draftsman*
Izobrazhenie vtoroi chasti feierverka predstavlennago pered Zimnim Eia Imperatorskago Velichestva domom...
Fireworks for empress Elizabeth of Russia held at the Winter Palace, Saint Petersburg, New Year's Eve, 1758
[Saint Petersburg?: n.p., 1758?]
Engraving. 18¾ × 26¾ in (47.6 × 68.0 cm)
From: "Fireworks Displays in Eighteenth-Century Russia." GRI, ID no. 92-F291

Fig. 21. Anonymous
Izobrazhenie feierverka pri torzhestvie brakosochetaniia ikh imperatorskikh vysochestv gosudaria velikago kniazia Aleksandr Pavlovicha i gosudaryni velikiia kniagini Elisavet Aleksieevny predstavlennago v Sanktpeterburgie Oktiabria...1793 goda
Fireworks held at Saint Petersburg, October 1793, for the marriage of the grand duke Alexander Pavlovich and grand duchess Elizabeth Alexeevna
[Saint Petersburg?: n.p., 1793?]
Engraving. 18¼ × 23¼ in (46.4 × 59.0 cm)
From: "Fireworks Displays in Eighteenth-Century Russia." GRI, ID no. 92-F291

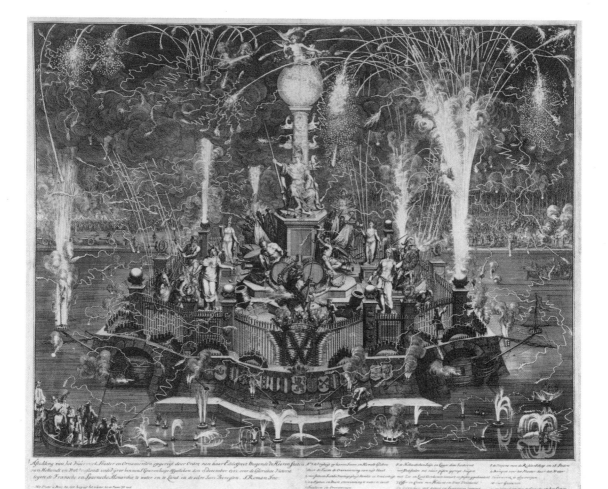

Fig. 22. Jan van Vianen (1660–1726), *draftsman and etcher*

Afbeelding van het vuurwerk theater en ornamenten... in de Vijver binnen s'Gravenhage afgestoken den 13. december 1702 over de glorieuse victorie tegen de Fransche en Spaensche monarchie...

Fireworks theater on the Vyver, The Hague, 13 December 1702, in celebration of the Dutch victory over the French and the Spanish

[The Hague?]: n.p., [1702?]

Etching. 20½ × 23¾ in (52.0 × 60.3 cm)

GRI, acc. no. 960068**

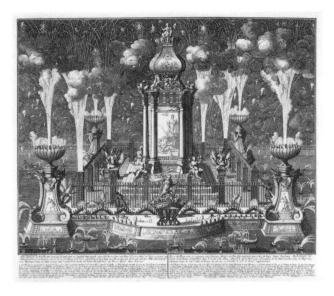

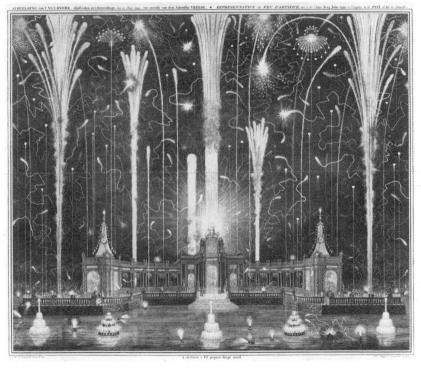

Fig. 23. Hendrick Pola (1676–1748), *draftsman*
Daniel Stoopendaal (died 1740), *engraver*
*Afbeeldingh van het theater met syn ornamenten en constigh
vuurwerck...in s'Gravenhage in de Vyver afgestoken op de
14 Juny 1713...*
Fireworks theater on the Vyver, The Hague, 14 June 1713,
in celebration of the Peace of Utrecht
The Hague: Anna Beeck, [1713]
Engraving. 20¼ × 23¼ in (51.4 × 59.0 cm)
GRI, ID no. 89-F9

Fig. 24. Jan Caspar Philips (ca. 1700–died after 1773),
draftsman and engraver
*Afbeelding van 't vuurwerk, afgestooken in s'Gravenhage,
den 13 Juny 1749 ter occasie van den Aakensche vreede*
Fireworks theater on the Vyver, The Hague, 13 June 1749,
in celebration of the Peace of Aix-la-Chapelle
The Hague: A. de Groot & Fil., [1749]
Engraving. 16⅜ × 19½ in (41.5 × 49.5 cm)
GRI, Brock Fireworks Collection, acc. no. P950001**-044

deal about prevailing modes of collecting, about systems of classification, and about material hierarchies (for example, what was considered worthy of preservation).

One such album, assembled in Russia at the end of the eighteenth century, brought together a large group of firework prints covering the years 1740 to 1796 (figs. 20, 21). While not exhaustive, the album represents nevertheless an extraordinarily single-minded enterprise devoted to the documentation of more than half a century of Russian pyrotechnical festivals. Its sixty-nine documentary engravings and fifteen drawings afford the rare opportunity to trace the evolution of a "public" art form over an extended period and in a specific context, with a tradition quite distinct from the rest of Europe and famous for its pyrotechnical ingenuity, excess, and exoticism.

These highly conventionalized, rigidly symmetrical, even hieratic representations are all remarkably similar compositionally. Each usually contains, for example, a richly decorated and centralized theater or machine always somehow removed from reality, the complete elimination of spectators, and a background awash with rather static fireworks. The Russian *feu d'artifice* seems to draw inspiration primarily from the French custom of splendid ostentation and insistent allegory, together with the German and Dutch tradition of a separate, clearly demarcated space, defined by specifically delineated boundaries—a fenced enclosure, that is, within which the spectacle unfolds. The fireworks themselves, however, are quite different from anything we have seen, or rather, their idiosyncratic rendering suggests this degree of otherness.

Removed Mysteries

We occasionally find a sense of the rarefied and transcendent in less imperial settings than Russia. The gradual evolution of an enclosed and isolated space for pyrotechnical displays, originating with the obvious need for safety from volatile explosives, can be said to have reached its apogee in the elaborate fireworks theaters erected from the end of the seventeenth to the middle of the eighteenth century in the Netherlands, particularly at The Hague, as, for example, in 1691, for the visit of William of Orange; in 1702, for the Dutch victory over the French (fig. 22); in 1713, celebrating the Peace of Utrecht (fig. 23); and in 1749, for the Peace of Aix-la-Chapelle (fig. 24). The engravings or etchings issued to commemorate these fetes are each a masterpiece of the printmaker's art, complex collaborative endeavors (like the spectacles themselves) involving the architect of the fireworks theater, the draftsman appointed to record the event and its site, and the engraver or etcher.

Rarely has the controlled chaos of a fireworks spectacle been so effectively conveyed as in these Dutch images, skillfully unifying "solid" architecture (the theater was floated in the Vyver, the small artificial lake in the center of The Hague) and transient fire. The recondite allegorical and metaphorical narrative, and the dense decorative detail embedded in these relatively small structures, necessitated lengthy printed explanations, or, at the

very least, a numbered table below the image keyed to individual items depicted in the print.[20]

Movement and variety are provided by the abstracting element of the pyrotechnics themselves. Particularly for the victory spectacle of 1702 (see fig. 22), the artist (Jan van Vianen) attempted to capture every variety of firework used. The result is a storm of lightning effects, exploding rockets, serpents, and fire fountains, terminating in trails of jagged flame against a background of billowing smoke. The print of 1702 provides an instructive contrast to that issued in 1749 for the Peace of Aix-la-Chapelle (by Jan Caspar Philips; see fig. 24), which, while filling its interstices with the zigzagging movement of serpents, has nevertheless a highly structured composition characterized by a rigid and symmetrical vertical grid. Its densely crosshatched background gives the print a resonance appropriate to its subject, a tightly woven web of modulating black suggestive of palpable smoke, which brilliantly frames the central glowing sun, a particularly effective use of the pure white of the uninked paper. While the etching of 1702 uses a Baroque pictorial language (shared with the spectacles of 1691 and 1713), the engraving of 1749 embodies the sparer vocabulary of midcentury, also reflected in the architecture of the theater itself.

The sensation of detachment from ordinary time and space that characterizes these highly focused images (close-up and cropped), where the intrusion of the real world is reduced to a minimum, was a logical outcome of the actual physical isolation of the theaters. This separateness must have been much more difficult to attain in a denser urban context, without the advantage of an inner-city body of water as at The Hague. That it was nevertheless a desired goal is particularly evident in the plates for the *Relation de l'inauguration solemnelle de sa sacrée majesté imperiale,* the fete book commemorating the ceremonial entry of Emperor Charles VI into Ghent in 1717.

The illustrations to the *Relation* successfully convey the impression of almost numinous transcendence such festivals were intended to evoke, a transformation, in other words, of the urban landscape (anchored in real time and space) into a "sacred" space outside of, or transcending, time. Michael Heylbroeck's rendering of the ephemeral fireworks structures erected in Ghent's Grande Place (fig. 25) includes neither participants nor spectators; what must have been a normally bustling market square has been scoured clean of human and extra-architectural presence. There is no indication that it stands at the center of a busy city, so divorced is it from its surroundings. Rather, the artist concentrated entirely on the potent verticality of the four fireworks towers that embrace the central column bearing the statue of Charles VI in the midst of a vast and empty zone. And while Jacob Harrewijn's etching of the night illuminations of the Hôtel de Ville, the three freestanding "pyramids," and the spray of fireworks launched from the town belfry (fig. 26) help to contextualize us in a recognizable urban environment, the sense of timelessness and distance is still emphatic.

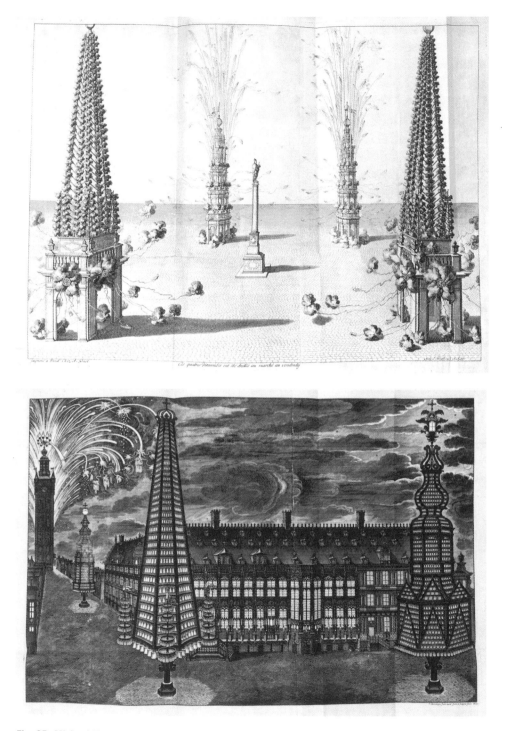

Fig. 25. Michael Heylbroeck (1635–1733), *etcher*
Ces quatres piramides ont été dressés au marché au vendredij
Fireworks structures in the Grand Place, Ghent, for the entry of Charles VI, 1717
Etching and engraving. 22¼ × 29¼ in (56.3 × 74.3 cm)
From: *Relation de l'inauguration solemnelle* (1719)

Fig. 26. Jacob Harrewijn (ca. 1660–after 1732), *draftsman and etcher*
Illuminations at the Hôtel de Ville, Ghent, 1717, for the entry of Charles VI
Etching and engraving. 21¾ × 29 in (55.2 × 53.6 cm)
From: *Relation de l'inauguration solemnelle* (1719)

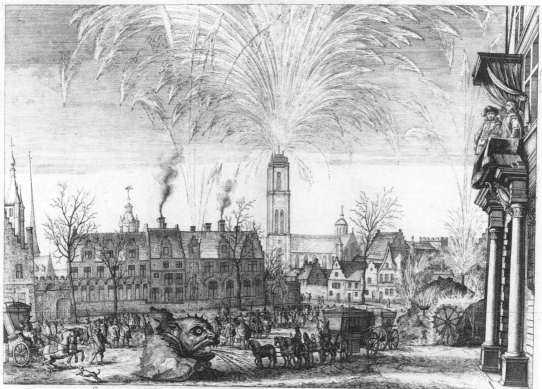

SVRGERE QVÆ RVTILO SPECTAS INCENDIA CŒLO FERNANDI SVCCENDIT AMOR.

Fig. 27. [Cornelius Schut (1597–1655) and/or assistants]
Surgere quae rutilo spectas incendia coelo Fernandi succendit amor
Fireworks in Ghent, 1636, for the entry of the Spanish prince Ferdinand
Engraving. 14¾ × 24¼ in (37.4 × 51.5 cm)
From: Beke, *Serenissimi* (1636)

The disjunctive and isolating effect of the prints parallels the intensely private experience of the fete book in which they appear and from which they literally unfold to reveal themselves in a series of disconnected and dissociative moments. The disorientation caused by such odd and unnatural excrescences on a normally identifiable landscape promotes the air of other-worldliness. The fireworks and illuminations function ritually—they help to define this space as sacred, ceremonial, set apart.

How very different Charles VI's Ghent is from the Ghent of the visiting Spanish prince Ferdinand eighty-one years earlier. In the fete book marking this state visit, the *Serenissimi principis Ferdinandi Hispaniarum* (Antwerp, 1636), we encounter a pronounced tension between the extraordinary and the mundane. Floats and fireworks machines illustrated in isolation from their urban environment assume the same thaumaturgic power and otherworldly air of the plates from the Ghent fete book of 1717. The penultimate engraving (fig. 27), however, lands us firmly back on earth. The messy, cluttered, haphazard, and improvised provincial character many of these festivals must often have had, qualities cleansed and refined for public consumption in the books produced to memorialize them, seeps out here, mud and all. The grotesque marine beast spouting fire looks rather hapless and comic against the backdrop of stolid Flemish merchants' houses. Even Ferdinand pays it, and the rest of the display, no heed. Instead, he looks outside the image, toward us, acknowledging the reader's more significant (because "eternal") presence.

A history of the early modern festival is a history of the frequently tense dialogue that characterized its negotiation between, among other things, the real and the fictive, the earthly and the celestial, urban space and sacred space, citizens and regent, city and empire. That these negotiations were often successful in alleviating that inherent tension is a testament to the power of artifice.

Roma Triumphans

One place in which the political dialogue succeeded especially well in early modern Europe, across both national and cultural boundaries, was the city of Rome. Figures 28 (1650), 30 (1687), and 29 (1728) may serve as a representative cross section of fireworks spectacles put to political purpose in the highly charged, profoundly symbolic milieu of Rome—as much idea as physical reality. As site of the Holy See and capital of Christendom, the city had long supported an international community, secular and ecclesiastical, in the form of embassies, academies, national colleges, and churches. Throughout the seventeenth and eighteenth centuries Rome was perhaps the most cosmopolitan of European urban centers. It was also the most ritualized. Like the Church that gave it meaning, Rome existed in time and out of time by nature of its symbolic presence; it betook of the eternal. Any ceremony, any festival, thus automatically participated in the numinous aura of Holy Rome, assuming a significance greater than was possible elsewhere. The symbolic

and the celebratory merged there in unique ways. Fireworks also assumed a resonance consistent with Rome's larger meaning. The annual fireworks display from the Castel Sant'Angelo (the so-called Girandola) became, over a period of several centuries, the most famous and most enduring pyrotechnical spectacle in Europe, while the eighteenth-century "Festival of the Chinea," also celebrated annually, achieved a similar authority, not the least because it was scrupulously documented.[21]

The appropriation of sacred and ancient public space common in Rome may be seen in such an image as Dominique Barrière's etching of Carlo Rainaldi's decorations for the Easter celebrations held in Piazza Navona in the Jubilee year of 1650 (see fig. 28). The elaborate tabernacles at each end of the Piazza, as well as the two fire-spitting obelisks, are temporary structures erected specifically for the event, as is the circumscribing fence bedecked with candles for night illumination. The fireworks themselves are downplayed in the print, the emphasis placed firmly on Rainaldi's impressive architectural transformation of the space into an appropriate site for a paschal liturgical procession.

The 1687 fete celebrating the convalescence of Louis XIV, held at the French national church, Trinità dei Monti, above the Piazza di Spagna (see fig. 30), is a particularly fine example of the Roman festival as undisguised propaganda. To announce Louis's recovery in Rome was to announce it to the world. Coming only two years after the public celebration, in the same place, of the Revocation of the Edict of Nantes, it also affirmed the continuity of Louis's reign and the perpetuation of the draconian edict that persecuted French Protestants.

The façade of the Trinità, brilliantly illuminated by monumental candelabra, was transformed by temporary decoration into an intricate allegory of Louis's reign. In the print, the *Grand Girandola,* or fireworks finale, made up of six thousand rockets, appears to descend upon the church like an immense parachute. The centerpiece of the decorative program was the figure of Eternity seated on a triumphal chariot drawn by four horses, itself a *fuoco d'artificio* (fireworks spectacle), and flanked by two smaller girandoles of three hundred rockets each. The whole of the Piazza di Spagna, the normally barren hill rising up to the French church (the Spanish Steps were completed only in 1728), the square in front of the Trinità, the Trinità itself, and the space above and beyond it have all been transformed into a great temporary outdoor theater. The privileged audience of this spectacle is accommodated in two covered platforms dominating the foreground, while music is provided by an orchestra at middle ground. The print's upper half, however, contains the real performance—the church as theatrical machine transfigured by sophisticated stage effects, illuminations, and fireworks that, in their canopied shape, seem to provide the French nation with protection from adversity. The unusually great size of the print, designed by Felice Delino and engraved by Vincenzo Mariotti, emphatically highlights the importance attached to the event.

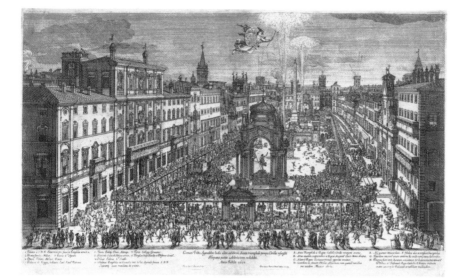

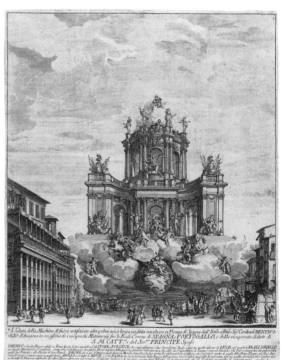

Fig. 28. Dominique Barrière (1618–1678), *draftsman and etcher*
Circum urbis, agonalibus ludis olim caelebrem, dicata triumphali pompa Christo resurgenti Hispana pietas caelebriorem rediddit. Anno jubilei 1650
Easter procession with fireworks in the Piazza Navona, Rome, 1650
[Rome: n.p., 1650]
Etching. 15½ × 24¾ in (39.3 × 62.8 cm)
GRI, acc. no. 970004**

Fig. 29. Gio. Paolo Pannini (ca. 1691–1765), *draftsman*
Filippo Vasconi (ca. 1687–1730), *engraver*
Veduta della machina di fuoco artifiziato . . . fatta innalzare in piazza di Spagna . . .
Fireworks machine in the Piazza di Spagna, Rome, 4 July 1728, for a double marriage of the Spanish and Portuguese royal families
[Rome: n.p., 1728]
Etching. 24½ × 18¾ in (62.2 × 47.6 cm)
GRI, ID no. 1362-284

Fig. 30. Felice Delino (active second half of 17th century), *draftsman*
Vincenzo Mariotti (active end of 17th–beginning of 18th century), *engraver*
Rejouissances publiques pour le restablissement de la santé de sa majesté tres chrestienne Louis le grand, faites a Rome...
Fireworks at Trinità dei Monti, Rome, 1687, in celebration of the convalescence of Louis XIV
Rome: n.p., 1687
Etching. 31 × 22 in (78.8 × 55.8 cm)
GRI, "Collection of Festival Prints," acc. no. P910002*

The fireworks spectacle celebrating the double marriage that united the Spanish and Portuguese royal families was held in the same location forty-one years after the fete for Louis XIV (see fig. 29). And yet, without learning this from the text below the image, we would be hard-pressed to identify the Piazza di Spagna, enveloped as it is by a vast cloud supporting an equally prodigious two-story classical temple. This print accentuates, above all, the profound difficulty of reconstructing ephemeral architecture from such visual records. There is little sense of corporeality here, and even less of an underlying supporting structure. We confront two very different worlds in this space, the one penetrating and mediating the other—a blurring of real and surreal spaces. The great floating temple, with its dramatically posed inhabitants and levitating globe against which a winged Amor disports, looks like an alien spaceship descending upon a phlegmatic urban citizenry, a few of whom point and gesticulate but most of whom pay scant attention. Our sense of disorientation is only enhanced by the absence of pyrotechnics; this is a fireworks machine without fireworks. The text makes clear that its importance lies in its narrative content, which metaphorizes while validating royal authority—in this case, Spanish and Portuguese, though the roles are, ultimately, interchangeable.

Homo Pugnans

Surely one of the most extraordinary fireworks images ever produced, a fantasy concocted by Jean Appier Hanzelet in his treatise on military and recreational fireworks, *La pyrotechnie* (Pont-à-Mousson, 1630), effectively unites war and play in a battle of the elements, raging in constant and violent flux beneath a cosmos controlled by an opposing sun and moon (fig. 31). Here, art and artillery collide, the perfect marriage of Hanzelet's theme *Marte et Arte* (see fig. 1).

And yet Appier's fantasy—its flame-filled ship that almost certainly alludes to the mysterious, deadly Byzantine "Greek fire" (the secret to which was lost in the Middle Ages), its skirmishing warriors wielding blazing swords, its riot of mortars and rockets and flying dragons, its spinning airborne Catherine wheel—finds its precedent in reality. In the week-long wedding festivities held at Düsseldorf in June of 1585, published as the *Fürstliche Hochzeit* (Cologne, 1587), with text by Theodor Graminaeus, we discover all of Hanzelet's basic ingredients among the various elements of the elaborate allegorical fireworks battles held on the Rhine (figs. 33, 34): a naumachia, soldiers brandishing firearms, an immense Catherine wheel, flying creatures. In addition, sea beasts do battle, a fire club–bearing Hercules destroys a many-headed Hydra, and a mock fortress is consumed in flames.

This, the basic syntax of the early recreational fireworks spectacle, emerging as it did from the language of war, was codified by the second quarter of the seventeenth century in works like John Babington's *Pyrotechnia; or, Artificiall fireworks* (London, 1635), whose plate 19 (fig. 32) somewhat haphazardly conflates castles, ships, and soldiers; or in Joseph Furttenbach's

Halinitro-pyrobolia (Ulm, 1627), where the conventions of floating fortress, ship, double-headed eagle, and rail-riding, fire-breathing dragon, spring fully formed. The last two—eagle and dragon—may be seen in action in Joannes Bochius's *Descriptio publicae gratulationis,* the ceremonial entry of Archduke Ernst into Antwerp in 1594 (fig. 35), atop rather primitive multitiered poles supporting barrels of burning pitch. The great sophistication that could be achieved, even within the conventional forms, is evidenced by the remarkably inventive water devices created for Louis XIII's visit to Lyons in 1622 (fig. 36). It is not unlikely, in fact, that Hanzelet's plate of seven years later (see fig. 31) was inspired by Pierre Faber's for *Le soleil au signe de Lyon* (fig. 37).

The formative ingredients common to early pyrotechnical treatises are also found in a distinct class of German fireworks spectacle, the *probefeuer-werke,* or practice fireworks, exhibitions put on by local experts and their students. These "exercises" were duly engraved and distributed as both news-worthy events publicizing the success of the display and as advertisements proclaiming the skill of the master in a highly competitive field. The concern with accuracy in these images reflects their condition as reportage. An un-usual illustrated broadside like figure 38 united coverage of a notable con-temporary event with a cautionary moral: "He who climbs high has far to fall, and he who loves danger will die in danger." Thus, the "famous surgeon" Dr. Carl Bernoju (at Regensburg, 4 January 1673) "in a display of recre-ational pyrotechnics as artistic as it was wanton," transformed himself into a human firework by means of "many firecrackers and small rockets tied to his body and limbs, and even on all his fingers." Like the more conventional fly-ing dragons we see in the manuals, Dr. Bernoju descended a long rope, engag-ing in acrobatics as he self-immolated ("looking more like a burning devil than a man"). The spectacle ended, of course, in disaster, as the print demon-strates in a continuous narrative technique in which the doctor is pictured twice—still attached to the rope at the beginning of his routine, and in a pool of fire and smoke and broken limbs on the pavement below.

The text of the broadside ends with an admonitory verse: "Another Icarus wished to fly into the air / But like the other one had to fall earthward / With the only difference that this one burned / While the other found his grave in cold water." Fireworks function, here, on a moral level, as hubris, feckless public display, wanton and wasteful: "to set foot outside one's profession is dangerous and leads to the audacity of one who stands firmly on a stage but yet would rather trust his life to a sheer, slippery rope."[22]

41

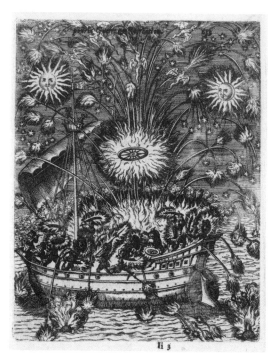

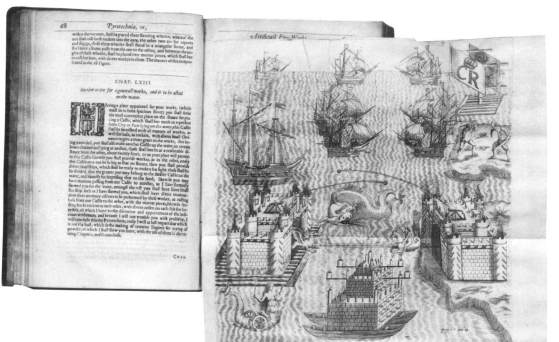

Fig. 31. Anonymous
Fireworks naumachia
Engraving. 9¼ × 6½ in (23.5 × 16.5 cm)
From: Appier Hanzelet, *Pyrotechnie* (1630)

Fig. 32. Anonymous
A generall worke, and is to be acted on the water
Engraving. 12 × 13⅜ in (30.5 × 34.0 cm)
From: Babington, *Pyrotechnia* (1635)

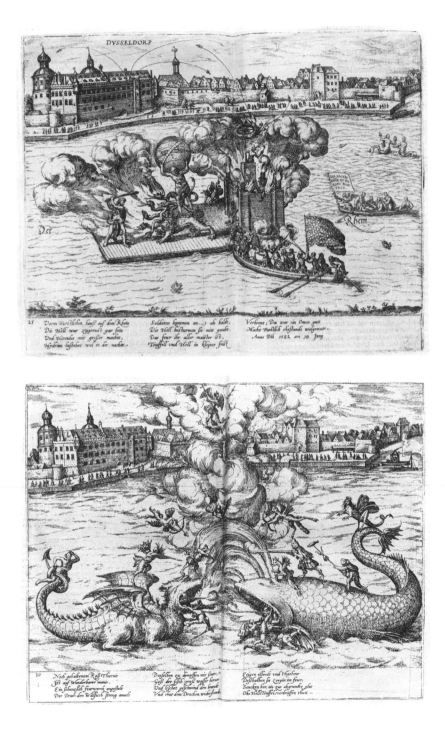

Fig. 33. [Franz Hogenberg (died ca. 1590), *draftsman?*]
Vorm Furstlichen hauß auf dem Rhein...
Fireworks naumachia on the Rhine at Düsseldorf, 18 June
1585, for the marriage of the duke of Jülich
Etching. 10⅝ × 13¾ in (27.0 × 35.0 cm)
From: Graminaeus, *Beschreibung* (1587)

Fig. 34. [Franz Hogenberg (died ca. 1590), *draftsman?*]
Nach gehaltenem Roß Thurnir...
Fireworks machines in the form of sea monsters on the
Rhine at Düsseldorf, June 1585, for the marriage of the
duke of Jülich
Etching. 10⅝ × 13¾ in (27.0 × 35.0 cm)
From: Graminaeus, *Beschreibung* (1587)

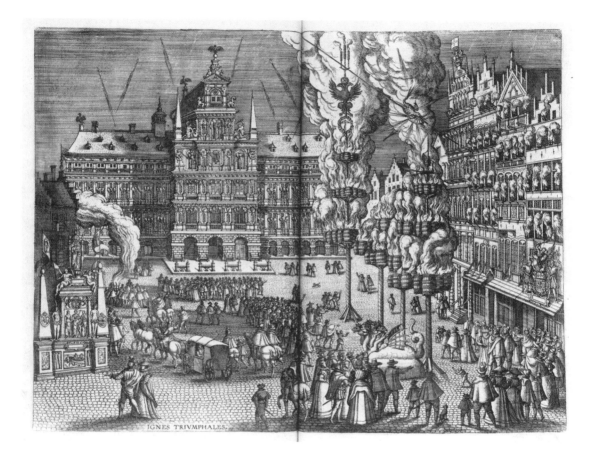

Fig. 35. Anonymous

Ignes triumphales

Fireworks display in Antwerp, 14 June 1594, for the entry of Ernst, archduke of Austria

Engraving. 14⅞ × 19¼ in (37.5 × 49.0 cm)

From: Bochius, *Descriptio* (1595)

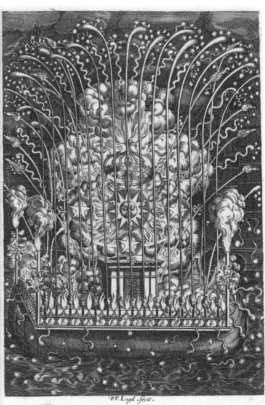

Fig. 36. Pierre Faber (active first half of 17th century), *engraver*
Fireworks machine in Lyons, 11 December 1622, for the entry of Louis XIII
Engraving. 8 × 12 in (20.3 × 30.5 cm)
From: *Soleil* (1623)

Fig. 37. Pierre Faber (active first half of 17th century), *engraver*
Fireworks machine in Lyons, 11 December 1622, for the entry of Louis XIII
Engraving. 12 × 8 in (30.5 × 20.3 cm)
From: *Soleil* (1623)

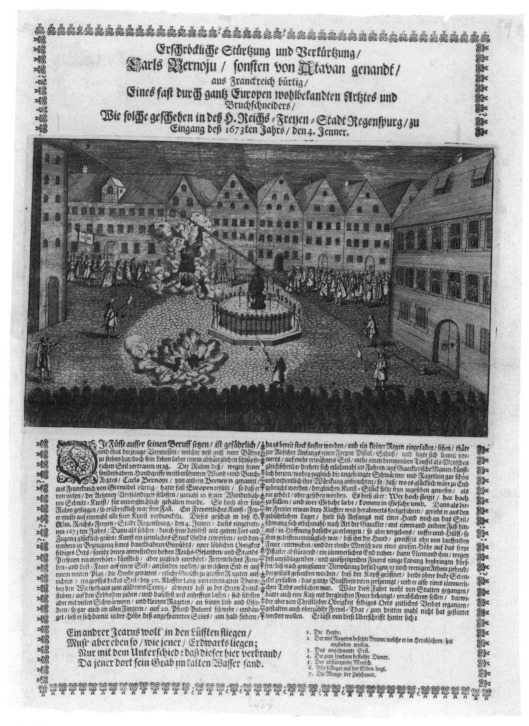

Fig. 38. Anonymous

Erschröckliche Stürtzung und Verkürtzung Carls Bernoju…in deß H. Reichs-Freyen-Stadt Regenspurg zu Eingang deß 1673ten Jahrs den 4. Jenner

Exhibition of pyrotechnical acrobatics by Carl Bernoju, Regensburg, 4 January 1673

[Regensburg?: n.p., 1673?]

Letterpress with engraved illustration. 16 × 11¾ in (40.7 × 29.7 cm)

GRI, Brock Fireworks Collection, acc. no. P950001**-016

Part II. Fireworks and the Sublime

Jean-Louis de Cahuzac, whose *Encyclopédie* entry defined the Enlightenment position on fireworks ("In all the Arts it is necessary to paint. In the one that we call *Spectacle,* it is necessary to paint with actions"), chose as his beau ideal for a fireworks presentation a highly allusive example from literature: "Has there ever been anything as important to the art of fireworks as the battle between the archangels of good and evil," he queried:

> Is not the action itself supposed to take place in the sky? The sublime Milton provided the details. Following your imagination, excited by this great image, draw the attack, the battle, the fall. Paint the magnificent spectacle of the good angels' moment of triumph. Carefully measure the spectacular effects to which such a great subject gives rise in abundance.[23]

It is safe to assume that Cahuzac intended to provide the reader-artificer with a trope, a pyrotechnical paradigm into which has been condensed a complete image of what such a spectacle should accomplish. But any eighteenth-century reader would also have responded immediately to Cahuzac's calculated reference to "the sublime Milton." By midcentury the notion that Milton was the great modern exemplar of the poetic sublime had long been a commonplace.

Cahuzac's choice of Milton's *Paradise Lost* as the model for a successful fireworks display suggests a perceived alliance, then, between the phenomenon of pyrotechnics and the concept of the "sublime" as it was understood in the eighteenth century. Nor would we be disappointed if we were to turn to what might be called the manual of the eighteenth-century sublime, Edmund Burke's *A Philosophical Enquiry into the Origin of Our Ideas of the Sublime and Beautiful* (London, 1757). Burke's influential treatise was largely a codification of previously scattered and unconnected, though already by this time somewhat hackneyed, aesthetic ideas that had been germinating in France and England at least since Boileau's translation of the ancient rhetorician Longinus's *On the Sublime* in 1674. With Burke, however, there is an important shift away from the sublime as merely "lofty," a change of direction that will characterize the definition of the term for the rest of the century. In his section "Of the Sublime," he explains that:

> Whatever is fitted in any sort to excite the ideas of pain, and danger, that is to say, whatever is in any sort terrible... or operates in a manner analogous to terror, is a source of the sublime; that is, it is productive of the strongest emotion which the mind is capable of feeling.... When danger or pain press too nearly, they are incapable of giving any delight, and are simply terrible; but at certain distances, and with certain modifications, they may be, and they are delightful....[24]

But terror alone is not necessarily conducive to sublimity, which is where other Burkean categories ("Infinity," "Magnificence," or "Vastness") come into play. "Magnificence," in particular, concerns us:

> *Magnificence* is likewise a source of the sublime. A great profusion of things which are splendid or valuable in themselves, is magnificent. The starry heaven...never fails to excite an idea of grandeur.... The number is certainly the cause. The apparent disorder augments the grandeur.... Besides, the stars lye in such apparent confusion, as makes it impossible on ordinary occasions to reckon them. This gives them the advantage of a sort of infinity. In works of art, this kind of grandeur, which consists in multitude, is to be very cautiously admitted; because, a profusion of things is not to be attained, or with too much difficulty; and, because in many cases this splendid confusion would destroy all use, which should be attended to in most of the works of art with the greatest care; besides it is to be considered, that unless you can produce an appearance of infinity by your disorder, you will have disorder only without magnificence. *There are, however, a sort of fireworks, and some other things, that in this way succeed well, and are truly grand.* (I, xii; italics mine)

So, for Burke, the right sort of fireworks (he does not specify which) may achieve "an appearance of infinity by...disorder," which produces magnificence and is thus capable of sublimity. Significantly, Burke classifies fireworks under his discussion of (and caveat concerning) works of art. Fireworks are not merely pleasant amusements, but are to be understood as works of art in their own right. This is consistent with Cahuzac's nearly contemporaneous *Encyclopédie* entry.[25]

Fear mingled with pleasure is no novelty with Burke. The novelty lies, instead, in his codification of it. And though we see a dramatic rise of these ostensibly contradictory emotions in the second half of the eighteenth century, they had, nonetheless, been previously articulated and (relevant to our purpose) within a pyrotechnical context. As early as 1661, Jean de La Fontaine (in a letter describing the splendid festivities at the chateau of Vaux-le-Vicomte, built by Louis XIV's unlucky superintendent of finance, Nicolas Fouquet) asked his correspondent to "imagine the racket, the crashing and the hissings...of those blazing columns," where "one sees war rage between the children of thunder, the one against the other combatant, flying and pirouetting; there was a terrible din [*un bruit épouvantable*], that is to say, an agreeable din [*un bruit agréable*]."[26]

The published account of the "Feste di fuochi" (Fireworks festival), held in Parma in 1724 to celebrate the election of Pope Benedict XIII, uses a highly poetic language to describe its *mise-en-scène:*

> [Thus] began the evening's entertainment, a competition of thunder.... The trumpets sounded, conveying feelings of joy, not signs of war; swordplay, but without blood; duels, but without risk; killing, but without horror. There were weapons—

both the lances of play and of caprice—not carried in the midst of terror, but simply for innocent amusement. The canvas of the sky was a great battlefield, where [rockets] raid delightfully [and] strike unarmed: shots of pure explosion...[27]

The narrative of the "Feste"—at least as outlined in the program—is a narrative of war. The independent fireworks serve as a grand prelude to the pitched battle that will follow, the centerpiece of which is an extraordinary *macchina* in the form of an impenetrable fortress. But the text makes clear that this is a *guerra giocosa*, a "mock" war. Thus, battle is subverted by play, *homo ludens* triumphs over *homo pugnans*. Jean de La Fontaine and the poet-author of the *Feste di fuochi* employ war as a metaphor for fireworks, an association implicit in a form of amusement that evolved out of what was originally a purely (or primarily) military function. What is significant here, however, at least in the context of the eighteenth-century notion of the sublime, is the recognition that the *terribilità* of war can be an experience that elicits pleasure when it resembles, but is not in actuality, war; that the loud noises and brilliant lights, the cacophonic explosions and bursting rockets are intrinsically satisfying to the spectator, granting a frisson of delight mingled with fear. It is but a short step from this to Burke's definition of the sublime as terror at a remove.

But how do these speculations—philosophical, aesthetic, literary—translate to the visual sphere? How are we to consider, in the context of the sublime, *representations* of fireworks? One unequivocally sublime painter (that is to say, an artist perceived as such by his contemporaries), the Englishman Joseph Wright of Derby, undertook to paint at least four quintessentially sublime fireworks paintings, all of the same subject: the famous "Girandola" at the Castel Sant'Angelo in Rome. The most successful of these is also the smallest, dated circa 1774–1775 (pl. 6). It depicts the finale over the castle from which the display was fired (the so-called Girandola, though the term was often used to signify the entire spectacle). Wright of Derby rendered an enormous umbrella of cascading, luminous orange-and-white fire, disturbed only by a long plume of billowing smoke from the accompanying cannon fire and the mortars themselves, the whole ensemble dramatically resembling an erupting volcano. Several stray rockets race wildly toward the picture frame, while in the left distance stands St. Peter's basilica, bathed in the brilliant glow of the fireworks display and outlined by the thousands of torches used to illuminate its façade on such occasions.

The canvas's similarity to an erupting volcano is not coincidental. The Girandola's pendant painting is, in fact, the eruption of Naples' Mount Vesuvius (pl. 5). Appropriately, Wright of Derby placed the volcano and the Castel Sant'Angelo in the corresponding part of each canvas (the right background), the one more effectively to mirror the other. Wright himself wrote of these two sublime phenomena that "the one is the greatest effect of Nature the other of Art that I suppose can be" (15 January 1776); and a reviewer of the Royal Academy exhibition of 1778 called another of Wright's pairs of Vesuvius and the Girandola "wonderful examples of sublimity."[28]

Fig. 39. Luca Ciamberlano (active 1599–1641), *engraver*
Fireworks machine representing the victory of the empire
over its rebellious subjects, for the visit to Rome of
Emperor Ferdinand III, February 1637
Engraving. 14¾ × 9¾ in (37.5 × 25.0 cm)
From: Manzini, *Applausi festivi* (1637)

Fig. 40. [Luca Ciamberlano (active 1599–1641), *engraver*]
Fireworks machine representing the victory of the empire
over heresy, for the visit to Rome of Emperor
Ferdinand III, February 1637
Engraving. 14¾ × 9¾ in (37.5 × 25.0 cm)
From: Manzini, *Applausi festivi* (1637)

Fig. 41. [Luca Ciamberlano (active 1599–1641), *engraver*]
Fireworks machine representing the victory of the empire
over the Ottoman Turks, for the visit to Rome of Emperor
Ferdinand III, February 1637
Engraving. 14¾ × 9¾ in (37.5 × 25.0 cm)
From: Manzini, *Applausi festivi* (1637)

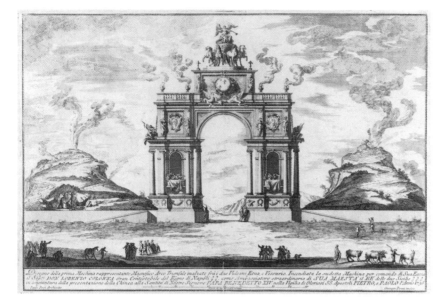

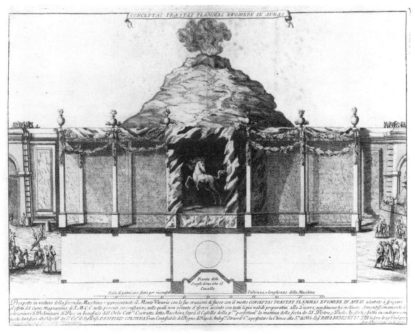

Fig. 42. Giuseppe Pozzi (active 1723–1765), *etcher*
Disegno della prima machina rappresentante magnifico arco trionfale inalzato frà i due vulcani Etna, e Vesuvio…
Fireworks machines representing Mount Etna and Mount Vesuvius, for the Festival of the Chinea, Rome, June 1756
[Rome: n.p., 1756]
Etching. 15¼ × 24⅝ in (38.8 × 62.5 cm)
From: "Feste della Chinea." GRI, ID no. 95-F0

Fig. 43. Andrea Rossi (active 1727–1775), *etcher*
Prospetto in veduta della seconda macchina rappresentante il monte Vesuvio con le sue eruzioni di fuoco…
Fireworks machine representing Mount Vesuvius, for the Festival of the Chinea, Rome, 29 June 1727
[Rome: n.p., 1727]
Etching. 15⅝ × 20⅛ in (39.7 × 51.1 cm)
From: "Feste della Chinea." GRI, ID no. 1387-207

Prospetto dello spettacolo dato dal illmo. ed eccelso senato nella piazza d'Armi detta del mercato il di 2 giugno 1785 in occasione del passaggio delle L.L.M.M. siciliane

Fig. 44. Luigi Grattagrassi, *draftsman*
Ignazio Sclopis (died 1793), *engraver*
Prospetto dello spettacolo dato dal illmo. ed eccelso senato nella piazza d'Armi detta del mercato il di 2 giugno 1785 in occasione del passaggio delle L.L.M.M. siciliane
Fireworks machine representing Mount Vesuvius, erected in Bologna for the visit of Ferdinand, King of Naples and Sicily, 2 June 1785
[Bologna: n.p., 1785]
Aquatint. 17⅝ × 25 in (44.7 × 63.5 cm)
GRI, acc. no. 970004**

The Eruptive Sublime

The association of Vesuvius with the Castel Sant'Angelo Girandola did not originate with Wright of Derby; it had already entered the eighteenth-century aesthetic consciousness, although, notably, Wright took a literary trope and visualized it. The broader typological alliance of "volcano" and "fireworks" also had a long and distinguished history. A drawing representing a parade float (as fireworks structure) commissioned by the Rospigliosi family for the Roman "Carnevale" of 1668, shows a miniature erupting volcano drawn by twelve horses. A contemporary account describes it as "a Mount Vesuvius that sends forth from its mouth smoke and flame and, instead of pumice, quantities of confection," no doubt to the delight of the spectators.[29] Even by 1668 this was clearly an established "type" of ephemeral festival architecture.

Luigi Manzini's *Applausi festivi fatti in Roma per l'elezzione di Ferdinando III* (Rome, 1637) meticulously describes, in word and image, the remarkable festival commissioned by the cardinal of Savoy for the visit to Rome of the newly elected Emperor Ferdinand III in 1637. Its central feature was a fireworks machine simulating Mount Etna that underwent a series of intricate and fabulous metamorphoses over the course of three evenings (figs. 39–41). The spectacle's politically topical triple theme—the victory of the Holy Roman Empire over its rebellious subjects (the German Protestant princes currently at war with the Catholic Hapsburgs), over heresy (Protestantism), and over the Ottoman Empire (long the enemies of Hapsburg Austria)—was realized by means of a complex allegorical visual language that employed state-of-the-art engineering and startling stage effects. In a pyrotechnical tour-de-force that "ravished the eyes and made them sleepy with wonder and delight," dragons, chimeras, and other infernal beasts spat fire from gaping jaws, a sun and crescent moon did aerial battle, and cloud-borne figures rose and fell in a blaze of fire.

The emperor himself is identified with Etna's flames. "Some said that so many times had the image of his magnificence been rendered in marble, silver, gold, and bronze, here, for once, was his effigy in flames."

> Others claimed to see the renewal of the world predicted under his happy reign, the sign of this being the competition of all the elements together: fire lit from powder (which is also earth) in order to soar skyward, while water, raining down, filled the air; because here, with happy confusion, all four elements commingled, representing a joyful and prodigious, but regulated, chaos.[30]

The reference to the mingling of the four elements, found frequently in fireworks descriptions from the sixteenth to the eighteenth centuries, is not merely a *topos*. The early modern view of the cosmos held that all matter was made up of infinitely varying quantities of the elements of earth, water, air, and fire, arranged in ascending order of importance, fire being noblest. All four elements, it was believed, were perpetually at war with one another. Furthermore, they were in a constant flux of transmutation, one into the other,

and a state of unceasing mutability. The speech of Pythagoras in Book XV of Ovid's *Metamorphoses* synopsized this belief system. As proof of the perpetual mutability of nature, Pythagoras cited the example of Etna ("living almost, with many lungs to breathe through, sending out flames") which:

> Will not be fiery always in the future,
> And was not always fiery in the past.
> ...So volcanoes,
> Starved of their nourishment, devour no longer,
> Abandon fire, as they have been abandoned.[31]

Mount Etna as exemplar of nature and matter's unceasing fluidity and transience is, then, an ideal subject for a festival machine, a device almost as intrinsically ephemeral as the fireworks it houses. The Etna of the *Applausi festivi*, flames issuing from its breathing lungs, says "all matter is in flux," "nothing remains the same." Its very essence, its form, functions as a *speculum principis* (a mirror of the prince) as well as a memento mori (a reminder of mortality). Like Pythagoras's volcano, Manzini's, too, will finally abandon fire and be itself abandoned—the festival will end, the flames dissolve into air. The noblest element, fire, is a fitting symbol of Ferdinand's high office. It defeats the baser elements, with which it wars, and though chaos is inevitable, it is, under Ferdinand, a "joyful and prodigious" and, more importantly, a "regulated" chaos.

For the eighteenth-century "Festival of the Chinea," held annually in Rome, either Vesuvius or Etna (or both) appears frequently as *macchina* (see, for example, the festivals of 1727, 1738, 1750, 1756—figure 42—and 1767).[32] In the engraving illustrating the *macchina* for the second day of the Chinea of 1727 (the festival consisted traditionally of two days, for each of which a separate print was issued) we see an erupting Vesuvius built before the Colonna family palace (fig. 43). Below and apparently inside the structure, an outsized model of the Chinea (the name of the white horse given by the Kingdom of the Two Sicilies to the Pope through its Colonna representative) is shown rearing up on its hind legs as if responding to the angry natural force of the exploding volcano, or even, perhaps, its *primum mobile*, the metaphorical genesis of the mountain's destructive energy. The inscription on the engraving, which briefly describes and explains the image, reveals that "the second machine represents Mount Vesuvius with its eruption of fire... adapted to describe the effects of His Majesty's Magnanimous Heart."

The Chinea print for the second day of the festival of 1750 (pl. 7), a highly imaginative reconstruction no doubt deviating substantially from the actual *macchina*, purportedly re-creates the eruption of Vesuvius in 79 C.E. when Pompeii was destroyed. Specifically, it reproduces the moment at which the ancient Roman naturalist and writer Pliny the Elder, having ventured out of curiosity ("excessive curiosity" the inscription avers) too close to the volcano, succumbs to the mountain's sulfurous gases and dies of suffocation. But what

makes the image interesting is the unselfconscious manner in which it blends the ancient and the modern. It is, in fact, nearly impossible to locate Pliny among the animated, toiling clusters of contemporary (that is, eighteenth-century) figures that swarm around and upon the mountain like inquisitive tourists, which, indeed, most of them are. The inscription states that "today this terrible marvel has become peaceful enough [a peace that would not last long, given the sudden and violent degree of volcanic activity from about 1750 to 1820] under the happy dominion of His Majesty, the King of the Two Sicilies, ... demonstrating that even inanimate objects are inclined to imitate the great placability of His Royal Clemency." This is an extraordinary assertion to make, notwithstanding its conventionally obsequious tone—that Vesuvius itself, this *terribile Meraviglia* of nature, should emulate the king's pacific character. Here, nature kneels before the civilizing forces of a properly governed dominion, and, like an obedient subject, Vesuvius acquiesces to the superior force of royal placability. Such a view, while befitting an absolutist monarch, was fast becoming an anachronism, and would soon be tested in both the cultural and political arenas.

Ironically, while the inscription warns against Pliny's *eccessiva curiosità*, it nevertheless states that "at present both natives and foreigners alike converge [upon Vesuvius] in order to satisfy their curiosity by ascending to its summit without danger; but the truly wonderful thing is that they may safely descend into the Mountain's viscera to investigate with impunity its rare qualities." The terrible marvel has been pacified and domesticated, has become, in effect, a subject of study for amateurs and scientists who scrutinize it like the cadaver of some great felled beast of an extinct species. The "Festival of the Chinea" thus functions as a kind of ritual of exorcism, apotropaic in purpose, intended to demonstrate that science, wisely tolerated under an "enlightened" monarch, subdues and controls a docile Nature, and that all is well, and shall remain so, in the Kingdom of Naples.

The city of Bologna held at least two festivals in the eighteenth century with Vesuvius as fireworks *macchina:* one in 1738 for the marriage of Carlos of Spain, king of Naples and Sicily, and another in 1785 for the visit of King Ferdinand (Carlos's son) and his consort, Maria Carolina, for which a handsome aquatint was executed (fig. 44). The latter shows Vesuvius dramatically erupting with fireworks from its central crater and from orifices up and down its declivities. Through an effective modulation of color and tone (for which aquatint was particularly well suited), the engraver (Ignazio Sclopis) evocatively captured the jagged, wispy calligraphy of thousands of airborne rockets exploding in unison against an inky night sky.

By the latter half of the eighteenth century, while fireworks could be made to resemble erupting volcanoes, volcanoes themselves (or more specifically Vesuvius) could also experience a reversal of sorts. Even for those most inclined to observe the rules of scientific restraint in the interests of empirical accuracy, Vesuvius erupting had become yet another spectacle exploited for the public's diversion.[33]

Sir William Hamilton did as much as anyone to advance real knowledge about the nature of volcanoes through his assiduous observing and recording of Vesuvian activity from 1764 to 1800 while resident in Naples as England's "Envoy Extraordinaire" to the King of the Two Sicilies. In his book *Campi Phlegraei: Observations on the Volcanoes of the Two Sicilies,* quoting a letter of 1766 that he had written to the Royal Society in London, Hamilton recalled his ascent of the mountain:

> The 30th [of March]...the mouth of the Volcano threw up every moment a girandole of red hot stones, to an immense height.... Mr. Hervey...was very much wounded in the arm some days before the eruption, having approached too near, and two English gentlemen with him were also hurt. *It is impossible to describe the beautiful appearance of these girandoles of red hot stones far surpassing the most astonishing firework.*[34]

Twice Hamilton uses the term *girandole,* and then feels compelled to make a comparison, albeit a negative one, to "the most astonishing artificial firework." "Artificial firework" is, of course, the English equivalent of the French *feu d'artifice* and the Italian *fuocho d'artificio,* but it is also meant to stand in contradistinction to the "natural" fireworks of Vesuvius, and parallels as well the commonly drawn differentiation between the artificial and the natural sublime. Hamilton's inclusion of the anecdote about Hervey and the two gentlemen is meaningful, as this is a perfect juxtaposition of danger and pleasure, the ingredients required to induce the Burkean sublime. Of course, by not keeping a safe distance, the three "excessively curious" Englishmen crossed over the fine line separating the sublime from the merely terrifying.

By 1779, however, Hamilton, resisting (or so he claimed) the temptation to use "poetical" language, reversed his former negative:

> As many poetical descriptions of this eruption should not be wanting, I shall confine mine to simple matter of fact, in plain prose...without aiming in the least at a flowery stile. The usual symptoms of an approaching eruption, such as rumbling noises, and explosions within the bowells of the Volcano...were manifest...during the...month of July, and towards the end of the month, those symptoms were increased to such a degree, as to exhibit in the night time *the most beautifull fireworks that can be imagined.*[35]

Here, Hamilton, the sober empiricist, succumbs to his own admonition against "a flowery stile."

In 1778, four Dutchmen made an extended visit through southern Italy and Sicily. One of them, Nicolaas Ten Hove, described his Vesuvian experience:

> Dierkens, Van Nieuwerkerke, and the painter [Louis Duclos], who had been there three days before, had described enormous hardships, but at the end *the noblest fireworks display in the world*, an imposing thunder, explosions of enflamed

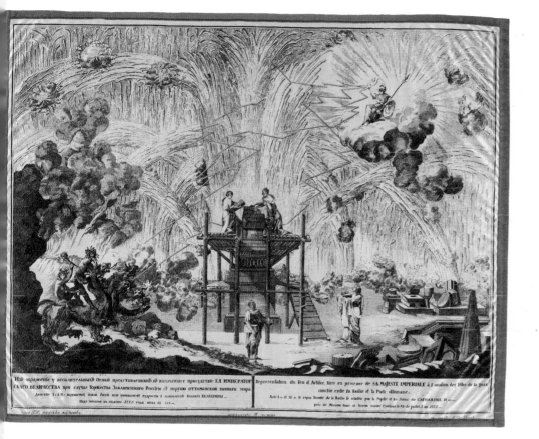

3. Matvei Fedorovich Kozakov (1738–1812), *draftsman*
...isei Emel'ianovich Fedoseev (born 1745), *engraver*
...obrazhenie uvesielitelnykh ogniei, predstavlennykh v vysochaishee prisudstvie Eia Imperatorskago Velichestva pri sluchae
...rzhestva zakliuchennago Rossieiu s Portoiu Ottomanskoiu vechnago mira
...reworks spectacle outside Moscow, 23 July 1775, celebrating the conclusion of the Russo-Turkish War (First of three
...ngravings: Acts I and II)
...oscow: n.p., [1775?]
...ngraving (bistre on satin). 19⅝ × 24⅛ in (49.9 × 61.3 cm)
...RI, ID no. 1370-250

masses rising to a height of a thousand feet and falling with a crash into the mouth or nearby.... Our hearts beat with fear and pleasure.... A most beautiful and terrible adventure we had.... Three times we enjoyed this sublime but, if truth be told, a little frightening, spectacle.[36]

Ten Hove's descriptive language is imbued with the post-Burkean spirit of the sublime—the dependence of the pleasurable, for its effect, upon the terrible. By 1778 this paradoxical essence of the sublime had become a cliché, and Vesuvius, if it had not existed (and had not contrived to erupt with such happy frequency), would have had to have been invented.

One of William Hamilton's visitors and admirers, the remarkable Prince Leopold Friedrich Franz von Anhalt-Dessau, was not content with the memory of Vesuvius but determined to reproduce it on the grounds of the vast park he created between 1764 and 1805 at Wörlitz, near Dessau. The park, in the English landscape manner, was the first of its type in Germany. Johann Wolfgang von Goethe, who visited in 1778, was delighted by it: "it has altogether the character of the Elysian Fields," he wrote, "one wanders around without asking where one started from or is going to."[37] Wörlitz provided the inspiration for Goethe's transformation of the park at Weimar, and it has been suggested that it inspired the setting for his novel *Die Wahlverwandtschaften* (The elective affinities). The final aim of Wörlitz was to show the visitor "the riches and marvels of the world—natural, scientific, and historical—which the wisdom of the ruler had chosen to exemplify in the monuments erected in his park."[38]

Certainly the most extraordinary of the Prince's re-creative reminiscences was the miniature Vesuvius (called *Der Stein,* "the rock," begun in 1788 and completed by 1796) that he had constructed on an island devoted to the landscape of southern Italy (complete with columbarium, nymphaeum, and a reduced copy of Hamilton's Villa Emma in Posillipo). A colored aquatint of 1797 by Karl Kuntz depicts the volcano as it was intended to be seen under ideal circumstances, that is, in a state of eruption (pl. 9). Contemporary accounts make it clear that the *Stein,* in addition to being educative, was meant to be sublime in its reception.

Karl August Böttiger described the experience in his *Reise nach Wörlitz* of 1797:

Now one continues up another spiral staircase...and, when one steps out onto an open shelf, one stands in amazement at the foot of a fire-spewing mountain.... The contrast [with the pleasant vista of the park below] is that much more horrifying when one turns around and sees the conically peaked fiery chasm behind one. Its sides are flecked, tiger-like, with yellow-brown stripes and overflowing lava wonderfully rendered from iron slag and yellow alumina [with] an appearance that even Hamilton himself would find strangely unexpected in a volcano that he had just climbed for the 104th time.... [T]o give this most terrifying of all natural spectacles its highest perfection, water can be pumped by a motor from the lake below

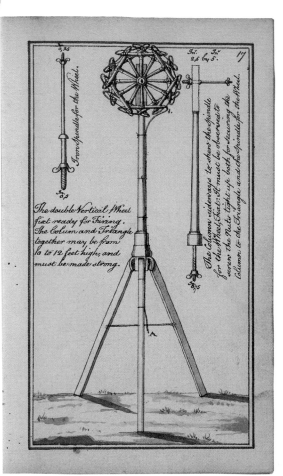

Pl. 1. John Maskall
Double vertical wheel
Drawing with pen, black ink, and grey wash. 6½ × 4 in (16.5 × 10.0 cm)
From: Maskall, "Artificial fireworks," unpublished manuscript
GRI, acc. no. 920091

Pl. 2. Anonymous
Large fire wheel
Graphite, watercolor, and gold leaf. 7¾ × 6¼ (19.7 × 15.9 cm)
From: "Beschrijving van kunst vuurwerken," ur manuscript
GRI, acc. no. 970037

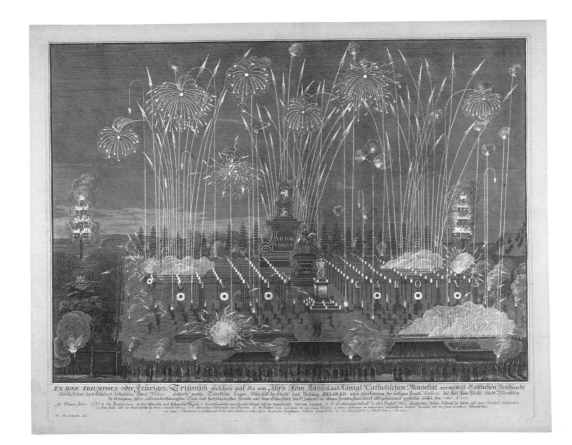

Pl. 4. Wolfgang Magnus Gebhardt (active first half of 18th century), *draftsman*
Ex Igne Triumphus, oder Feuriger Triumph, welchen auf die von Ihro Röm. Kaijserl. Catholischen Maijestät vermittelst Göttlichen Beijstands... Victori eroberte ganze Türckische Lager, Übergab der Stadt und Vestung Belgrad...
Fireworks display in Nuremberg, 7 September 1717, in celebration of the defeat of the Ottoman Turks at Belgrade
[Nuremberg: n.p., 1717]
Engraving (printed in red ink). 24½ × 31 in (62.2 × 78.7 cm)
GRI, Brock Fireworks Collection, acc. no. P950001**·026

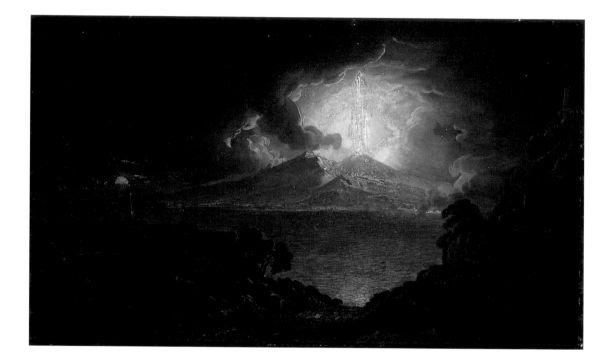

Pl. 5. Joseph Wright of Derby (1734–1797)
Vesuvius
ca. 1774–75
Oil on canvas. 16¾ × 28 in (42.5 × 71.1 cm)
Private collection, courtesy of Spink·Leger Pictures, London

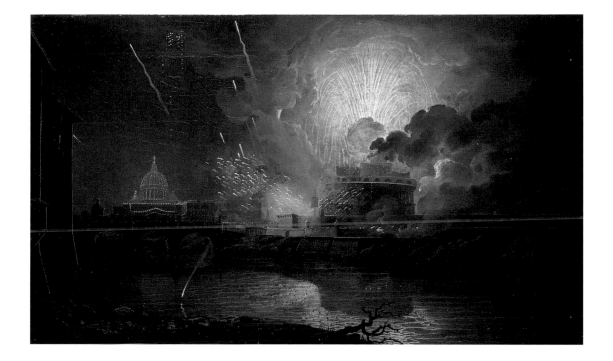

Pl. 6. Joseph Wright of Derby (1734–1797)
Firework display at the Castel Sant'Angelo
ca. 1774–75
Oil on canvas. 16¾ × 28 in (42.5 × 71.1 cm)
Birmingham Museums & Art Gallery, Birmingham, England
Acc. no. P34'61

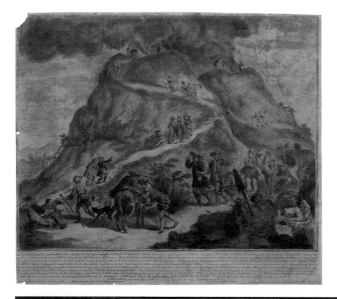

Pl. 7. Francisco Preciado de la Vega (1713–1789), *draftsman*
Miguel de Sorellò (ca. 1700–ca. 1765), *etcher*
Prospettiva della seconda macchina de fuochi artificio…
Fireworks machine representing Mount Vesuvius with Pliny the Elder, for the Festival of the Chinea, Rome, 1750
[Rome: n.p., 1750]
Hand-colored (watercolor) etching. 15⅜ × 17¾ in (39.0 × 45.2 cm)
From: "Feste della Chinea." GRI, ID no. 95-F0

Pl. 8. Pietro Fabris (active 1756–1779)
A night view of the current of lava, that ran from Mount Vesuvius towards Resina, the 11th of May 1771
Hand-colored (watercolor and gouache) etching. 18 × 13¼ in (45.7 × 33.6 cm)
From: Hamilton, *Campi Phlegraei* (1776)

DER STEIN

Pl. 9. Karl Kuntz (1770–1830)
Der Stein zu Wörlitz
1797
Color aquatint. 20⅛ × 26⅜ in (51.0 × 67.0 cm)
Kulturstiftung Dessau-Wörlitz, Wörlitz, Germany
Inv. no. IV-371

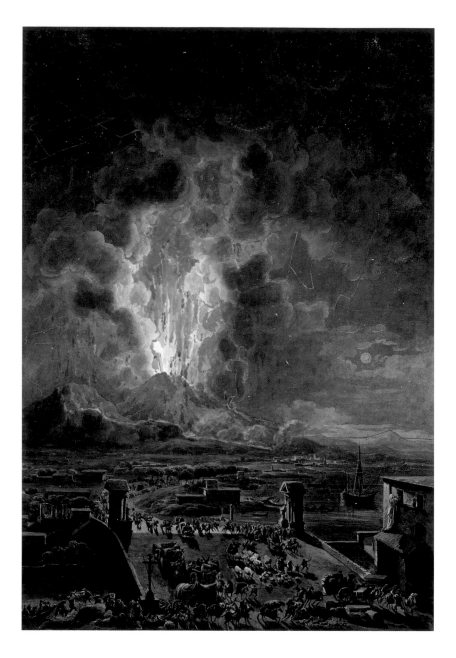

Pl. 10. Francesco Piranesi (1756–1810), *etcher*
Louis-Jean Desprez (1743–1804), *watercolorist*
The eruption of Vesuvius
[Rome?: n.p., 1783]
Hand-colored (watercolor and gouache) etching. 27½ × 18¾ in (69.7 × 47.5 cm)
Nationalmuseum, Statens Konstmuseer, Stockholm, Sweden
Inv. no. NMG 627/1874

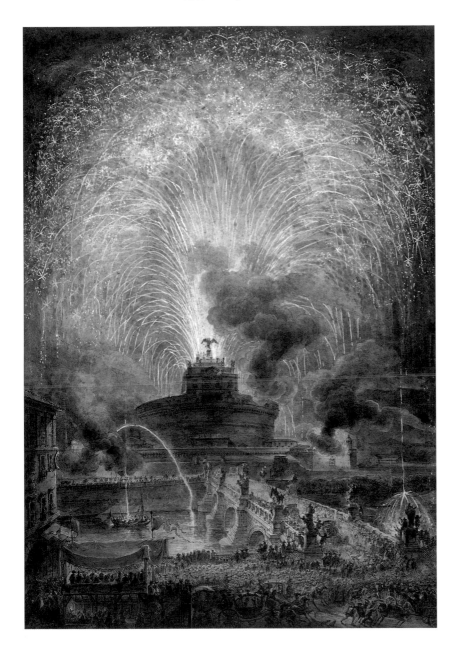

Pl. 11. Francesco Piranesi (1756–1810), *etcher*
Louis-Jean Desprez (1743–1804), *watercolorist*
The Girandola over Castel Sant'Angelo
[Rome?: n.p., ca. 1783]
Hand-colored (watercolor and gouache) etching. 26⅝ × 18⅛ in (67.6 × 46.4 cm)
GRI, acc. no. 960045**

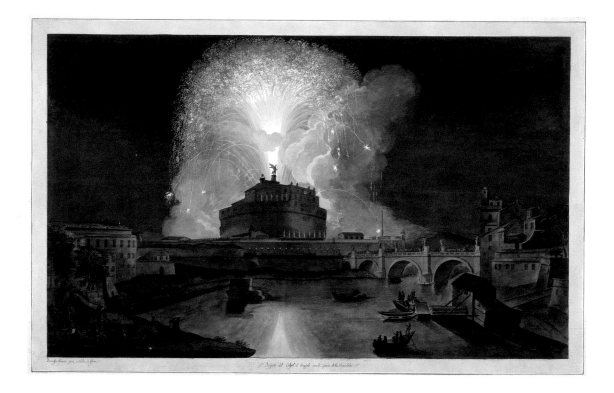

Pl. 12. Francesco Panini (1745–1812)
Il prospetto del Castel' S^{t.} Angiolo con lo sparo della Girandola
Castel Sant'Angelo, Rome, with the Girandola
[Rome?: n.p., ca. 1780–1785]
Hand-colored (watercolor and gouache) etching. 22⅞ × 34⅞ in (58.0 × 88.6 cm)
GRI, acc. no. 970025**

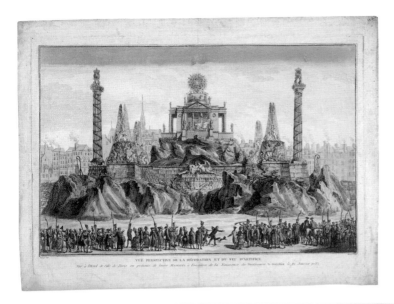

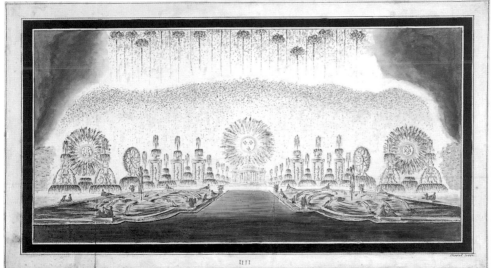

Pl. 13. Claude-Louis Desrais (1746–1816), *draftsman*
Voisard, *etcher*
Vuë perspective de la décoration et du feu d'artifice tiré à
l'Hotel de Ville de Paris … à l'occasion de la naissance de
monseigneur le dauphin, le 21 Janvier 1782
Fireworks on the Place de Grève, Paris, 21 January 1782,
on the occasion of the birth of the dauphin
[Paris: n.p. 1782?]
Hand-colored (watercolor) etching. 16¾ × 22¼ in (42.5 ×
56.5 cm). GRI, acc. no. 96.R.19

Pl. 14. Alexandre-M.-Th. Morel
Jean-Baptiste Torré (died 1780)
Fireworks design for the marriage of the dauphin (the
future Louis XVI) to Marie Antoinette, Versailles, 1770
Watercolor drawing. 13⅝ × 24½ in (34.6 × 62.2 cm)
GRI, Brock Fireworks Collection, acc. no. P950001** 049

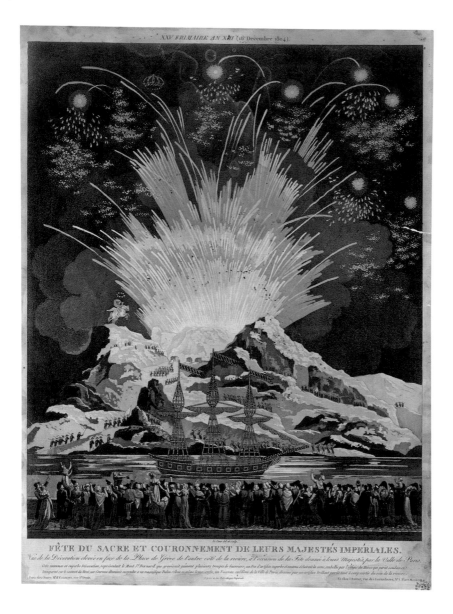

Pl. 15. Louis Le Coeur (active second half of 18th century), *draftsman and etcher*
Fête du sacre et couronnement de leurs majestés impériales
Fireworks spectacle in Paris, 16 December 1804, in celebration of the coronation of Napoleon
Paris: Bance, [1804?]
Etching and aquatint, bistre, and color. 17⅞ × 13⅛ in (45.5 × 33.3 cm)
GRI, ID no. 94-F134

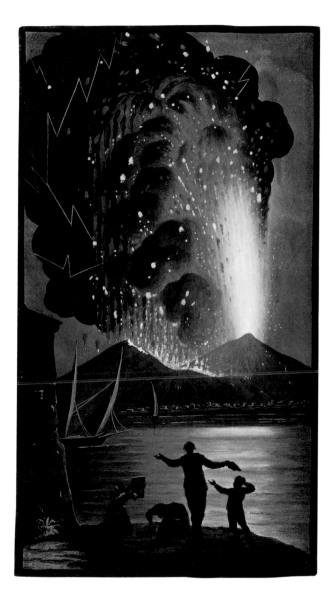

Pl. 16. Pietro Fabris (active 1756–1779)
View of the great eruption of Mount Vesuvius on Sunday night August the 8th 1779
Hand-colored (watercolor and gouache) etching. 13¼ × 18 in (33.6 × 45.7 cm)
From: Hamilton, *Supplement to the Campi Phlegraei* (1779)

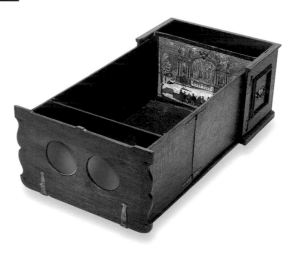

**Pl. 17. [Georg Balthasar Probst (active ca. 1765–1790),
engraver?]**
Pyrotechnicae repraesentationis splendidissimae typus
Fireworks spectacle in honor of Emperor Joseph II
[Augsburg?: n.p., ca. 1765–90?]
Hand-colored (watercolor) engraving (vue d'optique).
12⅞ × 17¾ in (30.7 × 45.0 cm)
GRI, Nekes Collection of Optical Devices, ID no. 94-F138

**Pl. 18. [Georg Balthasar Probst (active ca. 1765–1790),
engraver?]**
Same as plate 17, shown backlit

Pl. 19. Anonymous
Guckkasten (Peep show)
[Germany?, ca. 1750]
12⅞ × 19½ × 38¾ in (32.8 × 49.5 × 96 cm)
GRI, Nekes Collection of Optical Devices, ID no. 94-F138

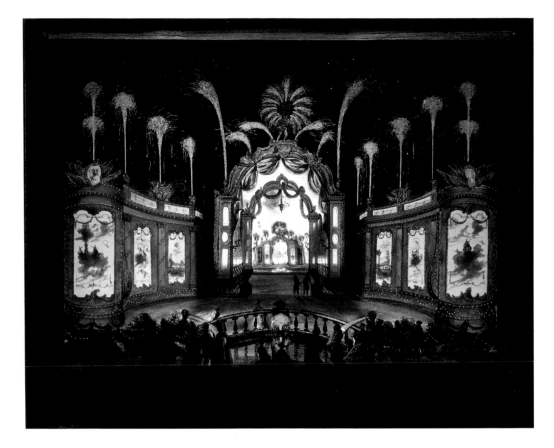

Pl. 20. Anonymous
Painted glass portable fireworks theater
[Place of manufacture unknown, 18th century]
13 × 16 × 4 in (33.0 × 40.6 × 10.2 cm)
Theater Instituut Nederland, Amsterdam

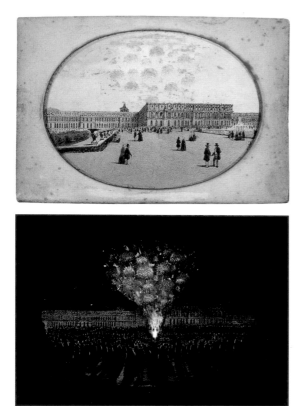

Pl. 21. Anonymous
Daytime scene at Versailles
[France?, second quarter of 19th century?]
Hand-colored (watercolor) lithograph. 4⅛ × 5⅞ in (10.4 ×
14.9 cm)
GRI, Nekes Collection of Optical Devices, ID no. 94-F138

Pl. 22. Anonymous
Nighttime scene with fireworks at Versailles
Same as plate 21, shown backlit

Pl. 23. Anonymous
Viewing device "Voyage où il vous plaira"
[France?, second quarter of 19th century?]
19¼ × 6 × 11 in (48.9 × 15.2 × 27.9 cm)
GRI, Nekes Collection of Optical Devices, ID no. 94-F138

up to the belly of the crater.... [W]hen the crater is filled with...fireworks...the rows of lamps quickly ignite and the terrible explosion begins....[39]

Struggling to imagine how the *Stein* would appear at night and in action, "when the entire salamander scene [is]...in its full glory," Böttiger studied Kuntz's recently issued aquatint, "made by the artist during those frightening minutes of crisis at the very scene.... Here, the most magnificent aspect of the whole spectacle, namely the reflection in the night water at the foot of the volcano, is brought out particularly well." Yet Böttiger could not refrain from qualifying his praise for Kuntz. In a note, he added: "One cannot deny [the artist] the achievement, claimed in the inscription, that it is drawn from nature, and yet it results in completely different expectations as the spectacle in nature does."[40]

The language used by Böttiger (and by his contemporary August Rode, author of the *Beschreibung des Fürstlichen Anhalt-Dessauischen Landhauses und Englischen Gartens zu Wörlitz* of 1798) is patterned after the impassioned accounts of visits to Vesuvius itself, and yet it comes off sounding like a parody of such language, just as the *Stein* (unintentionally) parodies its paradigm. The soldier, statesman, and prolific writer Prince Charles-Joseph de Ligne, who saw Wörlitz in the same years, wrote a much more breathless description of the *Stein* than either of his German contemporaries:

Jumping from your boat, you plunge into caves, catacombs and scenes of horror, through fearsome darkness and stairways. You emerge...into a fine Roman amphitheater.... And now fears seize you, you wish to escape, and must, perforce, climb up a narrow stairway. The darkness becomes more complete,...a sudden brightness dazzles your sight,...a door opens, light gleams from a beautiful statue in the middle of the room, and you realize...that it has come through yellow, star-shaped panes in the roof of this chamber....[41]

Ligne's fevered account evokes the language of Horace Walpole's Gothic romance *The Castle of Otranto*. Here, fear and pleasure commingle with surprise to bring about the sublime, although for Ligne this has nothing to do with the volcano's fireworks as it is unlikely, given the extreme rarity of performances, that he ever saw them. In fact, Böttiger's florid narrative of the *Stein*'s eruption may have been based primarily on Kuntz's print. This may then be a rare example of a work of "documentary" art prompting feelings of the sublime. Our only clue that the aquatint might itself have been perceived as sublime, albeit in a complex and ambiguous way, is Böttiger's acknowledgment that the artist succeeded in bringing out "the most magnificent aspect of the whole spectacle": its reflection in the night water. Nevertheless, the whole scene has a kind of domesticated wildness about it, aided by such romantic visual clichés as the stone arch used as a repoussoir device in the right foreground. The boat bearing a party of spectators has a further domesticating effect, suggesting a pleasant nocturnal outing that might end with a moonlight picnic.

The reductio ad absurdum of late eighteenth-century volcano lust is to be found, however, in William Hooper's *Rational Recreations*. In "Recreation 50," Hooper explains how to create, in your own backyard, an artificial earthquake and volcano:

> Grind fresh iron filings... with an equal quantity of pure sulphur... till the whole is formed into a fine powder.... [T]ake about fifty pounds of the above powder, and, burying it privately about a foot deep under the earth, you may safely predict that in about eight hours time the ground will begin to heave and swell, that it will send forth hot sulphurous steams, and at last, bursting into live flames, will form a true volcano.[42]

With Hooper's "rational recreation," designed to astound and amaze friends and family, the sublime is no longer either terrible (as with Burke) or didactic (as at Wörlitz), but has been reduced to a party trick, debased, vulgarized, domesticated. And the domesticated sublime is really just another way of describing the "picturesque."

The Poetic Sublime

We have come a long way from the Castel Sant'Angelo and its celebrated Girandola. A metaphorical connection has been established between the Castello and Vesuvius; fireworks, like volcanoes, were potentially ideal subjects for treatment within the aesthetic parameters of the sublime. Wright of Derby's choice of pendants thus fell under an already established *topos*, and it should come as no surprise that Onorato Caetani should explain in his *Osservazioni sulla Sicilia* (Rome, 1774) that the Castel Sant'Angelo Girandola was invented in imitation of a volcano, specifically the volcano on the island of Stromboli, northeast of Sicily, which emits flames reminiscent of rockets.[43] While this is probably a fanciful notion, Caetani, as a native Roman, was in a position to know the popular tradition and, as a man of great learning, an *erudito*, his opinion would have carried weight.

By 1820 the metaphor had become a commonplace. Mrs. Charlotte Eaton, in her popular guide *Rome in the Nineteenth Century*, wrote matter-of-factly of "the girandola, or great fireworks from the Castle of St. Angelo, which commenced by a tremendous explosion, that represented the raging eruption of a volcano."[44] And Gaetano Moroni, the Roman author of the monumental *Dizionario di erudizione storico-ecclesiastica,* similarly concluded that: "Especially the two... explosions or eruptions of rockets launched at the beginning and at the end [of the fireworks display] (which because of their shape give this spectacle the name *girandola*)..., assuming the form of an enormous fan of fire, can give one the idea of a great volcano."[45]

In addition to Wright of Derby's unprecedented juxtapositions of the Castello and Vesuvius, we find another pairing (pls. 10, 11), in a different medium (hand-colored etching) and format (vertical), from circa 1780 by Louis-Jean Desprez and Francesco Piranesi (son of the famous Giovanni Battista

Piranesi).[46] As they were part of a larger series, there is only internal evidence to prove that these were conceived as pendants, yet their formal similarities, coupled with Wright's well-known antecedent, make the intentionality of a pairing probable. The compositions' leftward list, the foreground bridge cluttered with spectators, the combination of fire and smoke strongly suggest that the artists perceived them (like Wright) as the finest examples of the natural and the artificial sublime.

If Francesco Panini's spectacular hand-colored etching of the Girandola (pl. 12) may be securely dated to the 1770s, then it must surely have influenced the Desprez-Piranesi etching of the same subject (see pl. 11), especially the manner and palette in which the fireworks are rendered: the brilliant red, yellow, and white umbrella of exploding and cascading rockets, and the great, bellying clouds of smoke that followed upon the combination cannon and girandola blasts. Panini plays down, nearly eliminating, the crowd of spectators (they are present, but so Lilliputian as to be virtually invisible) and, working in a horizontal format, greatly expands the night sky to create a powerful contrast of light and dark. Desprez and Piranesi, on the other hand, make their crowd emphatic, and, by selecting a vertical format, fill the upper half of the print with fireworks, thus reducing the contrasting sky to a minimum. At the same time, the sense of the sublime in the Panini (as in the Desprez-Piranesi) is overt, the connection with contemporary views of an erupting Vesuvius transparent and intentional.

Particularly the Desprez-Piranesi rendering of the Girandola calls to mind an excited description by the normally self-possessed neoclassical architect Robert Adam, written a quarter century earlier, in 1755. "It exceeded," he exclaimed:

> for beauty, invention, and grandeur anything I had ever seen or indeed could conceive. What was the grandest part of the operations they call the Girandola, being thousands of rockets which are sent up at one time, which spread out like a wheat sheaf in the air, each one of which gives a crack and sends out a dozen burning balls like stars, which fall gently downwards till they die out. They, to appearance, spread a mile, and the light the balls occasioned, illuminating the landscape, showed the Castle of Sant'Angelo, the river Tiber, and the crowds of people, coaches and horses which swarmed on all sides and appeared to me the most romantic and picturesque sight I have ever seen.[47]

Adam concluded that it made Rome look "horribly antique and pleasing."

But Robert Adam both follows and is followed by a long trajectory of ecstatic language used to describe the Girandola at Rome, a thread of language that weaves itself almost imperceptibly into the tropology of the sublime. The great impact on the imagination of those who witnessed the Girandola is attested to by the middle of the sixteenth century, although the earliest known mention of the display appears in the diary of Antonio di Pietro in 1410. In Vannoccio Biringuccio's *Pirotechnia* of 1540, the author

claimed "never to have seen such a thing in a festival," further maintaining that "when all the fire is lit and the guns go off, and the rockets, fire tubes, squibs, and balls go hither and thither, nothing can be seen but smoke and fire, and [truly] it seems then to be the fire imagined in hell."[48]

The event was traditionally divided into several parts: first, lanterns and torches placed within the castle merlons were lit, while at the same time salvos of cannon and mortar were fired. In response, the palaces across the Tiber set fire to large, strategically placed barrels filled with wood, hay, and tar. Then, stationary fireworks attached to poles as tall as the castle's lateral towers were set off, and finally, accompanied by cannon fire and trumpet blasts, airborne mortars and spinning girandoles were set off in a shower of fire and light.

On one of the earliest representations of the Girandola, an engraving by Giovanni Ambrogio Brambilla published by Claude Duchet in 1579 (fig. 45), we read that "it seems as if the whole city is on fire," that "the whole city trembles," and that, when certain of the rockets (the *soffioni*, or "dandelion rockets") "burst in the air in the shapes of stars it appears as if the sky has opened." During the finale, the inscription informs us, "it seems as if all the air in the world is filled with fireworks, and all the stars in the heavens are falling to earth—a thing truly stupendous, and marvelous to behold." In the print, the Castel Sant'Angelo is seen from directly across the Ponte Sant'Angelo on the city side of the Tiber river, an already canonical point of view for representations of the Castello. Three great sprays of fireworks erupt over the fortress, while cascading "stars" blanket the night sky to either side. The traditional flaming barrels of burning pitch add to the general conflagration, both in the foreground and on the castle walls. The gathered crowd, exclusively male, ignores the spectacle, engaged rather in conversation.

An engraving issued the following year, 1580 (with parallel text in Latin and Italian that, while truncated, closely follows the text of 1579), takes the "falling stars" simile a step further (fig. 46). Here, the sky appears literally to rain fire. Though clearly based on Brambilla's print, its primitive technique more effectively captures the descriptive language found in the earlier work ("it seems as if the whole city is on fire"). In contrast to the 1579 engraving, the crowd of spectators now takes significant notice, pointing and gesticulating, pitchforks and shovels poised, ready to smother any errant fires.

In a horizontal-format etching of the Castello dated 1692 (fig. 47), the technique is more sober and refined than we have seen (no doubt because the composition is based largely on a 1671 print, without fireworks, by G. B. Falda after a drawing by Bernini made to commemorate the restoration of the Ponte Sant'Angelo). The Girandola has been, to some degree, sanitized, at least in comparison to the engravings of 1579 and 1580, and the meticulously delineated fireworks, carefully composed into three distinct zones, now have a furry, frozen, intensely artificial quality about them, the print devoid of the chaos of its sixteenth-century predecessors. The audience, further reduced, includes a few women; no one, however, seems particularly interested in the

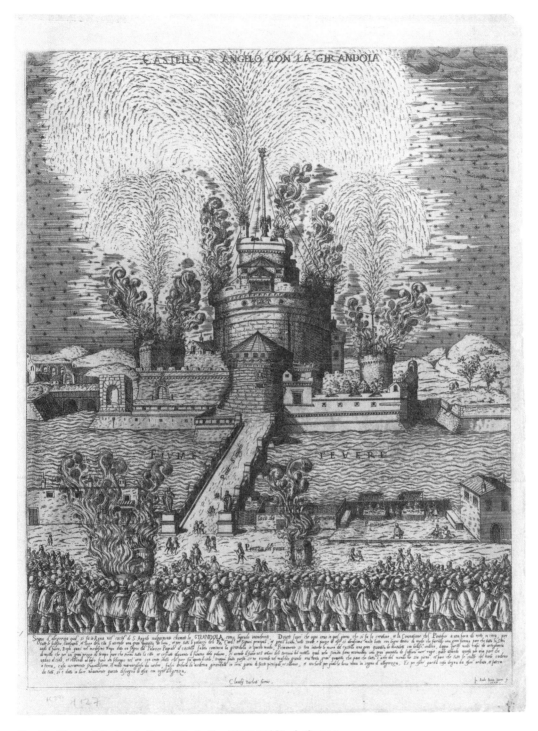

Fig. 45. Giovanni Ambrogio Brambilla (active 1579–1599), *draftsman*
Castello S. Angelo con la girandola
Castel Sant'Angelo, Rome, with the Girandola
[Rome]: Claude Duchet, 1579
Engraving
21½ × 15⅝ in (54.6 × 39.6 cm)
From: "Speculum Romanae magnificentiae." GRI, ID no. 91-F104

spectacle—this, presumably, the result of having been purloined from the earlier, fireworks-free, etching.

With Giovan Battista Galestruzzi's fireworks engraving of the stage set for the final act of Marco Marazzoli's and Giulio Rospigliosi's 1656 opera *La vita humana; overo, Il trionfo della pietà* (fig. 48), performed in Rome at the Barberini palace in honor of Queen Christina of Sweden, the castle and St. Peter's become a backdrop, a moralizing *mise-en-scène,* for a theatrical presentation. Unlike the documentary prints of 1579, 1580, or 1692, which were issued and sold individually, Galestruzzi's engraving illustrated, with three other plates, the published libretto of *La vita humana.* Its function, therefore, as well as its dependence on a text into which it is embedded, deviates from that of "autonomous" images of the Castel Sant'Angelo. This fact may account for the license it takes in altering the canonical view of the Castello established in the previous century. By siting St. Peter's at center stage, the basilica (the *fons et origo* of Christianity) assumes the perspectively determined locus of greatest importance. Its audience would not have failed to grasp this.

The opera is a moralizing allegory of "human life, or the triumph of piety," and, in the final act, personifications of:

> "guilt" and "pleasure" disguised like... "understanding" and "innocence," endeavor to cosen [i.e., deceive] "life" But... "understanding" and "innocence," coming forth in their true appearances...make her see her own errour and frailty, ...admonishing her that if she shall...think of death...she shall find whosoever thinks of death, never ceases to live well.[49]

The fireworks that concluded the opera, as seen in Galestruzzi's rendering, may be merely celebratory (the triumph of good over evil), or they may, in fact, fit into the moralizing structure of the narrative. That is, fireworks, whose brilliance is so rapidly extinguished (consumed in the very act of consummation) may here function as a kind of memento mori, and Life is, after all, instructed by her guides, Understanding and Innocence, to "think of death" in order to live well.

The highly poetic language of Gasparo Alveri's description of the Girandola (*Della Roma in ogni stato,* Rome, 1664) is characteristic of the written accounts of the spectacle for the next two centuries: a language which required no great leap to arrive at the discourse of the sublime. To Alveri, the scores of rockets, all launched at the same time, "resemble, by their quantity, velocity, and murmuring, a swarm of bees driven from their hive."[50] "[S]cattered across the sky, they are transformed into shining gold flames resembling a great vase of gilded flowers..., finally falling to earth like the purest stars" or like "golden rain."

The inevitably vulgarized end, however, of two and a half centuries of inflated prose directed toward one monolithic site[51] appears in the form of the following turgid, but highly amusing, ekphrasis from Charlotte Eaton's *Rome in the Nineteenth Century:*

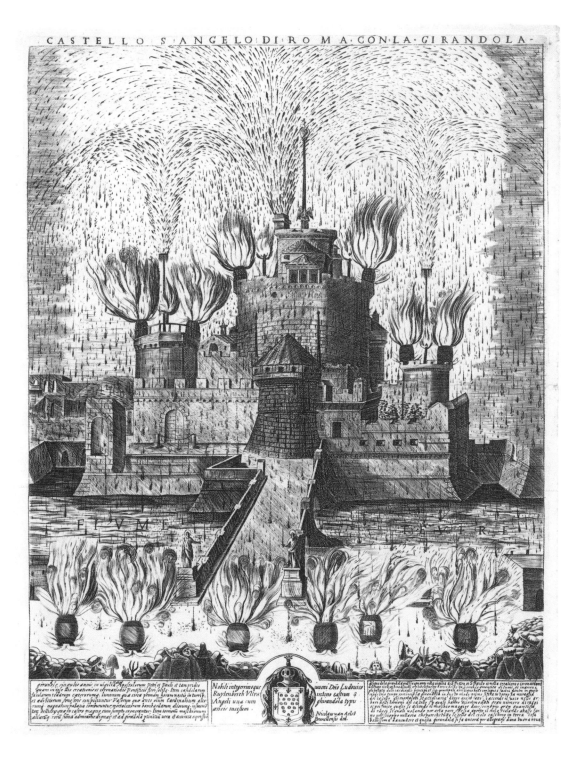

Fig. 46. Anonymous
Castello S. Angelo di Roma con la girandola
Castel Sant'Angelo, Rome, with the Girandola
[Rome?: N. van Aelst, ca. 1580]
Engraving. 20¼ × 15¾ in (51.5 × 40.0 cm)
GRI, acc. no. 970004**

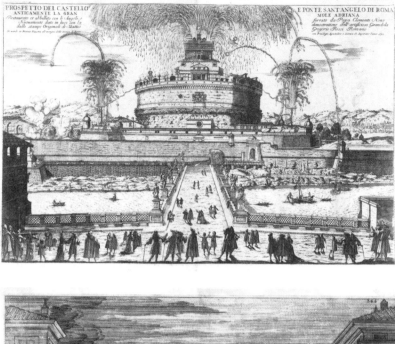

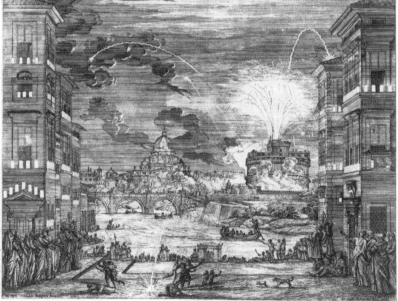

Fig. 47. Anonymous
Prospetto del Castello e Ponte Sant'Angelo di Roma anticamente la gran mole Adriana
Castel Sant'Angelo, Rome, with the Girandola
Rome: Matteo Gregorio de Rossi, 1692
Etching. 19 × 27⅛ in (48.2 × 68.8 cm)
GRI, acc. no. 970004**

Fig. 48. Giovan Battista Galestruzzi (1618–died after 1661), *etcher*
Final scene of the opera *La vita humana* by Giulio Rospigliosi and Marco Marazzoli
[Rome: n.p.], 1657
Etching. 13¼ × 16 in (33.6 × 40.6 cm)
GRI, acc. no. 970004**

Red sheets of fire seemed to blaze upwards into the glowing heavens, and then to pour down their liquid streams upon the earth.... Hundreds of immense wheels turned round with a velocity that almost seemed as if demons were whirling them, letting fall thousands of hissing dragons and scorpions and fiery snakes.... Fountains and jets of fire threw up their blazing cascades into the skies. The whole vault of heaven shone with the vivid fires, and seemed to receive into itself innumerable stars and suns, which, shooting up into it in brightness almost insufferable, vanished—like earth-born hopes.... [T]he whole ended in a tremendous burst of fire, that...almost seemed to threaten conflagration to the world.

But this great agent of destruction was here wholly innocuous. Man, who walks the earth, ruling not only the whole order of beings, but the very elements themselves, has turned that seemingly uncontrollable power, which might annihilate the very globe itself, into a plaything for his amusement, and compelled it to assume every whimsical and fantastic form that his fancy dictates. It alone, of all things in existence—reversing the order of nature—rises from earth towards the sky; yet even this he has bowed to his will.[52]

Incredibly, Mrs. Eaton might be describing Mount Vesuvius. Effectively blurring the discourse of the sublime with a dogmatic anthropocentrism reminiscent of the Chinea print of 1750 ("His Royal Clemency" placating volcanoes), she has accomplished perhaps as successfully as anyone the complete degradation of the sublime. As a category for philosophical speculation (at least for the present), the sublime is finished, having been trivialized beyond repair.

Goethe, thirty years before Charlotte Eaton's lurid effusions, had achieved a more delicate balance. He had been mightily impressed by the fireworks for the feast of Saints Peter and Paul in June of 1787, but reserved his particular praise for the illumination of the façade of St. Peter's which traditionally accompanied the Girandola. "The illuminations are spectacular," Goethe wrote in his journal:

like a scene from fairyland; one can hardly believe one's eyes. Now that I have learned to see objects as they are and not, as formerly, to supply with imagination what is not there, a spectacle has to be really grand before I can enjoy it.... To see the colonnade, the church and, above all, the dome, first outlined in fire and, after an hour, become one glowing mass, is a unique and glorious experience. When one thinks that, at this moment, the whole enormous building is a mere scaffolding for the lights, one realizes that nothing like it could be seen anywhere else in the world.... Then the blaze was over, and again the full moon softened the lights and made everything a fairyland again.

The fireworks were beautiful because of the setting, but they did not compare with the illuminations of the church. We are going to see them both a second time.[53]

The Erotic Sublime

This passage from Goethe's journal reveals more than the poet's appreciation for the "unique and glorious experience." Goethe frames his rapture within a broader objectivity: "Now that I have learned to see objects as they are," he announces, "and not, as formerly, to supply with imagination what is not there." This is Goethe the scientist, the naturalist, the disinterested empiricist speaking. It is in his nature to be conflicted—the poet-scientist at war within himself. And yet it is precisely his imagination at work when, in his novel *The Elective Affinities* of 1809, he weaves fireworks into the fabric of his narrative in an innovative, even radical, process of psychological metaphorizing; that is to say, fireworks are made to function as a metaphor for the psychological states of his condemned "lovers," Edward and Ottilie:

> Rockets roared up, cannons thundered, balls of fire rose, squibs curved down and burst, Catherine wheels hissed, first separately, then in pairs, then all together and with increasing violence, in succession and at once. Edward, his breast aflame [*dessen Busen brannte*], watched those fiery apparitions with eager satisfaction. Susceptible and agitated as she was, Ottilie found this roaring and flashing, bursting and fading more distressing than pleasurable. She leaned shyly against Edward, and her closenesss, her trust in him completed his feeling that she belonged to him entirely.[54]

The fireworks are a triumph for Edward, a triumph of the masculine over the feminine. This is a highly gendered moment; one in which Edward's active response to the fireworks is set against Ottilie's passive reaction. Ottilie, from fear, distraction, the internal conflict that characterizes her complex nature, succumbs to the inexorable force of the self-obsessed Edward. Edward's breast is "aflame"; Ottilie is "susceptible and agitated." This is the first time the two actually touch one another, and it is this touch (Ottilie leaning against Edward for protection), engineered by Edward through the device of the fireworks (his sexual energy), that activates the "irresistible fatality" (in Margaret Fuller's phrase) of Goethe's narrative. The near-drowning that occurred only moments before, as a direct result of the fireworks display, foreshadows the death of Edward's child as well as the deaths of Edward himself and Ottilie, the former consumed (like fireworks) by his own insatiable ardor.

In *The Elective Affinities*, then, using pyrotechnics as his metaphorical engine, Goethe created an erotics of fireworks, indeed an erotics of the sublime. He had earlier made this association, and in a context relevant to his allegorizing of fireworks. While in Naples in 1787 the poet had visited in her apartments the duchess of Giovene. The couple spent some time walking to and fro, deep in conversation as night fell, when suddenly the duchess flung open a shutter to reveal Vesuvius in full eruption: "the mountain roared, and at each eruption the enormous pillar of smoke above it was rent asunder as if by lightning.... It was an overwhelming sight.... When we resumed our con-

versation, it took a more intimate turn." Shortly after, Goethe observed that, "[s]itting in the foreground of this incredible picture [the duchess] looked more beautiful than ever, and her loveliness was enhanced for me by the charming German idiom in which she spoke."[55] Vesuvius, feminine beauty, intelligent conversation, the German tongue—all of these converge for Goethe (with the spectacle of the blasting volcano as essential dramatic catalyst and backdrop) to produce an atmosphere of arousal.

Wörlitz, too, provided Goethe with creative inspiration. Not only was it the stimulus for the park at Weimar, conceived and designed by Goethe and Duke Karl August, but, in all likelihood, it was the basis for the setting of *The Elective Affinities* as well. Goethe may, in fact, have had the *Stein* in mind when inventing his own fictional fireworks display. Having already made the associative connection between Vesuvius and erotics, it was but a short distance to the concatenation of fireworks (linked as they were with Vesuvius at Wörlitz) and erotics. And though we do not know if Goethe ever actually saw the *Stein*, he would surely have heard of it, and could have seen Kuntz's aquatint.[56]

Goethe was not, however, the first to link love with fireworks. The seventeenth-century English metaphysical poet Richard Crashaw, in his poem devoted to the mystic St. Theresa of Avila, *The Flaming Heart* (a work which is really a reflection upon an image of Theresa in an ecstatic state that Crashaw had seen and found wanting), wrote the following:

> Painter, what didst thou understand
> To put her dart into his hand!
> See, even the yeares and size of him
> Showes this the mother SERAPHIM.
> This is the mistresse flame; and duteous he
> Her happy fire-works, here, comes down to see.

St. Theresa's "happy fire-works" (like the arrow Bernini's celebrated sculpture of Theresa joyfully, gratefully, rapturously receives into her breast) are a metaphor for a state of ecstasy produced by spiritual union with God. But Crashaw's angel ("that fair-cheek't fallacy of fire"), in contradistinction to Bernini's participatory seraphim (and passive Theresa), functions as mere spectator, audience to the self-activated, self-immolating fireworks machine that is Theresa, self-engendering flames of spiritual love.

The poem, throughout, plays on male vs. female ("You must transpose the picture quite, / And spell it wrong to read it right; / Read HIM for her, and her for him; / And call the SAINT the SERAPHIM," and later, "Give HIM the vail, give her the dart"). Crashaw's fireworks, like his Theresa, are "male" ("One would suspect thou meant'st to paint / some weak, inferiour, woman saint"). He accuses the painter of mocking "with female FROST love's manly flame," an allusion to the theory of the four temperaments (allied to the four elements: earth, air, water, fire), wherein hot and dry are traditionally male

attributes, cold and humid, female. Goethe, too, alludes to the temperaments in *The Elective Affinities* (the title, a term from chemistry, refers to the fact that when certain chemical compounds are mixed, their component elements change partners—a metaphor for the novel's partner-swapping). Each of Goethe's four main characters corresponds to one of the elements, though Ottilie (who is associated throughout with warmth and light, and thus signifies fire) breaks with the old iconographic tradition.

At about the same time that Crashaw composed *The Flaming Heart*, the great French playwright Pierre Corneille, in his comedy *Le menteur* (The liar) of 1642, utilized fireworks within a context of sexual seduction. Like Goethe, Corneille's *feu d'artifice* takes place over water, enjoyed by lovers from a boat ("often water inspires fire," Corneille's "hero" remarks, meaning, of course, the fire of passion). In Corneille's verse: "Thousands and thousands of fireworks were launched heavenward … making a new day …, a flaming deluge attacked the water, so that one believed that the whole fiery firmament would have to fall from heaven to earth for them to war any more violently" (Act I, scene 5). Fire (the flame of passion), water (erotic turbulence), war (love's battlefield)—Corneille weaves these together in an exercise devoted exclusively to the art of seduction: fireworks equated with sexual conquest.

Love, if not seduction (at least not of the sexual sort), played a role as well in the political arena. The month of festivities celebrating the marriage of Emperor Leopold I to Margaret Theresa of Spain, in Vienna in 1666, began with one of the most spectacular and ambitious fireworks displays of the seventeenth century (this alone is notable, since fireworks traditionally *ended* festivals). Its theme was love, exemplified by fire—the love of the monarch for his subjects ("the Phoenix which consumes itself out of love for its people as the model of [His] Majesty"); the people for their sovereign ("to ignite the flames of their most humble submission"); Leopold for Margaret and Margaret for Leopold ("the purest devotion of the one," "the flaming obedience of the other.") (figs. 49–51).[57]

The Vienna marriage *feuerwerke* were shaped into an elaborate narrative, an allegorical pantomime in three acts. A re-creation of Mount Etna with the forge of Vulcan stood to one side, Mount Parnassus with the nine muses to the other, both framing, in the foreground, two castellated towers flanking trabeated arches bearing enormous hearts which were set ablaze by the god of marriage. In the background, the Temple of Hymen embraced a central altar upon which Jupiter's eagle ignited the "public pleasure fires." The numerous descriptions of the event narrate, in great detail, not simply the allegorical pantomime, but also the number and kinds of fireworks employed. The engravings give a rather good impression of what the event must have been like. Of course, in the individually issued prints (see fig. 49) (as opposed to the illustrations for the published description, *Von Himmeln entzindete*, where each act is accompanied by a separate plate—see figures 50 and 51), the artists were obliged to condense the three acts into one rather confused scene, though confusion (from the thousands of exploding rockets, the din of

musket and cannon fire, the trumpets and drums) must certainly have characterized the spectacle, a sound-and-light show of unprecedented scope and magnitude. Significantly, the engravers endeavored to differentiate the several kinds of fireworks used—the *stern feuern, feuer-pumpen, stern granaten,* and *racketen* (star fireworks, fire pumps, star grenades, and rockets).

This attempt to convey the visual and numerical accuracy of the fireworks finds its parallel in the meticulous textual descriptions. Especially in *Von Himmeln entzindete,* this is not merely enumerative but builds to a climax, firework upon firework, like a narrative, or a plot, or an argument. The Vienna fireworks spectacle was distinguished by excess—an excess of love (as sacrifice, devotion, obedience, duty, and, by implication, sexual passion), of noise and fire and quantity of pyrotechnics—all in the interest of political stability. An erotics of politics becomes, then, the foundation for immutable order, framed within the enduring discourse of classical mythology, and forged out of ever-threatening chaos (as exemplified by the imagery of war, transformed by Cupid into love, and converted by art into "pleasure fires"). Descriptive accuracy (also a kind of ordering, and thus allied against the forces of chaos), combined with abundance (signifying prosperity), proclaim power, the end product of order and stability.

The Political Sublime

Moving from an erotics of politics to a politics of the sublime requires no great shift. And while the consummation of the political sublime may be the *feu d'artifice* staged for the imperial coronation of Napoleon in Paris in 1804 (a spectacular re-creation of Mount Saint Bernard on the banks of the Seine), the way had been smoothly paved by the ancien régime twelve years earlier, and in virtually the same location. The fireworks display held on the Place de Grève in 1782 to commemorate the birth of the dauphin (the doomed son of Louis XVI and Marie-Antoinette) was celebrated with an ostentation not witnessed in the French capital for over a decade. Louis could ill afford such extravagance (the state's finances were in disarray), but all resolutions of economy were deferred in order to observe the succession-assuring arrival of the long-awaited heir to the throne. The prodigality of the festivities was in inverse proportion to the monarchy's power, and the spectacular *feu d'artifice* was no exception (pl. 13).

The fireworks machine consisted of a heroically proportioned Temple of Hymen (in which "the offerings of all France burned with a fire the more lively for the prosperity of the royal family and the dauphin"[58]), sited upon an enormous rocky promontory (order emerging from chaos, culture from nature), circumscribed by a masonry foundation wall, the whole ensemble enveloped by a "landscape" of rock and wild vegetation. To either side of the temple were several geysering fountains and two monumental spiraling columns (functioning like giant Roman candles), while surmounting it, a dazzling sun held a likeness of the dauphin himself—the future Sun King.

Many prints of this extraordinary machine were issued, of varying accu-

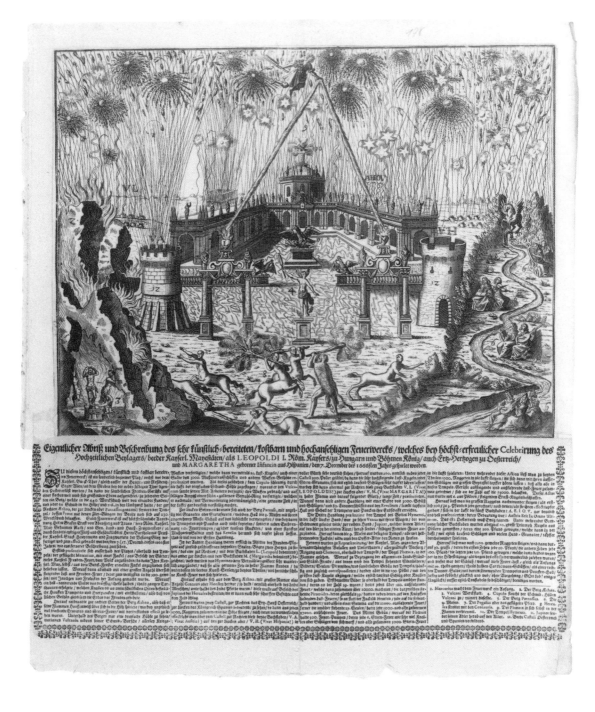

Fig. 49. Anonymous

Eigentlicher Abriß und Beschreibung des sehr künstlich-bereiteten kostbarn und hochansehligen Feuerwercks welches bey höchst-erfreulicher Celebrirung des Hochzeitlichen Beylagers beeder Kayserl. Mayestäten als Leopoldi I. Röm. Kaysers... und Margaretha geborner Infantin aus Hispanien den 7. December des 1666ten Jahrs gespielet worden

Fireworks spectacle in Vienna, 7 December 1666, for the marriage of Leopold I and Margaret Theresa

[Vienna: n.p., 1666]

Engraving. 18½ × 15½ in (47 × 39.3 cm)

GRI, acc. no. 840063**

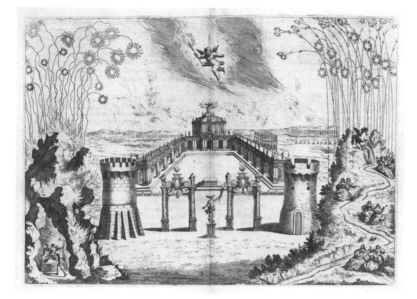

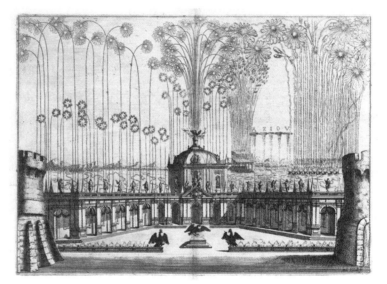

Fig. 50. Melchior Küsel (1626–ca. 1683)
Fireworks display showing Temple of Hymen with
Mt. Parnassus and Mt. Etna, Vienna, December 1666, for
the marriage of Leopold I and Margaret Theresa
Engraving. 11½ × 14½ in (29.2 × 36.8 cm)
From: *Von Himmeln* (1666)

Fig. 51. Melchior Küsel (1626–ca. 1683)
Fireworks display showing Temple of Hymen, Vienna,
December 1666, for the marriage of Leopold I and
Margaret Theresa
Engraving. 11½ × 14⅞ in (29.5 × 37.7 cm)
From: *Von Himmeln* (1666)

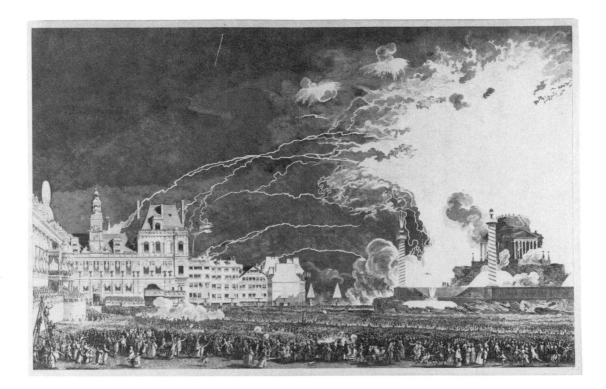

Fig. 52. Jean-Michel Moreau (called Moreau le jeune) (1741–1814), *draftsman and etcher*
Feu d'artifice offert au roi et la reine par la ville de Paris le 21 janvier, 1782
Fireworks on the Place de Grève, Paris, 21 January 1782, on the occasion of the birth of the dauphin
[Paris: n p , 1782?]
Etching (first state of three, before the addition of engraving). 18¾ × 29¼ in (47.6 × 74.3 cm)
GRI, acc. no. 970027**

racy and artistic quality. The most impressive, however, is an etching by Jean-Michel Moreau le jeune (fig. 52), in which, remarkably, the gargantuan machine is shunted to the right background, the real subject (along with the spectacularly rendered fireworks) being the mass of humanity in the Place de Grève.[59] One would not guess from the limitless sea of Parisians present (all the city, it seems, if not all France) that the Place was notoriously cramped, ill-suited to great public events. In fact, in order to allow for more viewing space, the machine was placed on the quay bordering the square. An elaborate gallery was also built perpendicular to the Hôtel de Ville (visible at the far left of the print), the better for their majesties to see the fireworks.

While the official account describes, approvingly, this "dignified spectacle" with its revolving and fixed cascades, its *jets en nappe, serpentaux, bombes, pots-à-feu,* and *piramides,* concluding with a great "Glory" and a *girandole* or *bouquet,* we will recall that the duc de Cröy was not impressed, criticizing the machine as too massive, too close, and insufficiently decorated, and labeling the fireworks a complete failure.

If we are to believe the duc de Cröy, then, the spectacle's "success" is an invention of Moreau le jeune. The artist's "interpretation" of the *feu d'artifice* depicts the grand finale, the right half of the print awash with explosive fire and cascading white light, bursting bombs and spinning girandoles, while the fading trails of expiring rockets, like spectral fingers, reach across the night sky to disturb the impassive neoclassical calm of the stately Hôtel de Ville. The whole thing seems a macabre prefiguration of the impending Revolution. But it is the massive exaggeration of size (of the square) and number (of spectators) that truly impresses. Moreau le jeune here achieves a potent statement of the political sublime: the seething mass of "loyal" subjects, hands raised in astonishment, agitated, movemented, in a frenzy of collective "approval" before the awful grandeur of the fire machine, all a metaphor for a monarchy *in extremis,* this the last splendid evocation of a dynasty on the verge of extinction—as ephemeral as the fireworks themselves. For better or worse, in Moreau le jeune the regime could not have found a better propagandist. How appropriate that he should have continued to prosper during the Revolution, applying his skills to the illustration of important Republican events.

Eight years later, in a different political climate, an English partisan of the French Revolution, Helen Maria Williams, using the language of the sublime, evoked the "Fête de la Fédération" (the most ambitious festival of the new regime, and a fitting parallel to the 1782 festivities):

[I]t is not to be described! One must have been present, to form any judgment of a scene, the sublimity of which depended much less on its external magnificence than on the effect it produced in the minds of the spectators. "The people, sure, the people were the sight!" ... Half a million ... assembled at a spectacle, which furnished every image that can elevate the mind of man; which connected the enthusiasm of moral sentiment with the solemn pomp of religious ceremonies; which addressed itself at once to the imagination, the understanding, and the heart! ... It

was the triumph of human kind; it was man asserting the noblest privileges of his nature; and it required but the common feelings of humanity to become in that moment a citizen of the world.[60]

But democracy soon cedes again to absolutism, just as the "Fête de la Fédération" gives way to Napoleon's coronation festivities of 1804 (pl. 15). The rocky foundation of the 1782 machine has, in Louis Le Coeur's impressive aquatint, swelled and expanded, like the Emperor's pride, into an *immense et superbe* replication of Mount Saint Bernard, the pass through which Bonaparte had crossed the Alps in 1800 to defeat the Austrians at Marengo. Troops of soldiers march toward its distant summit, while a monumental equestrian statue of *le héros* (Napoleon) strides atop one of its peaks. Perhaps the most arresting feature of the spectacle was an aerial balloon from which an enormous illuminated crown was suspended, this just visible in the upper-left corner of the print.

The whole grand edifice is almost certainly a recollection (or recapitulation, or monumental "realization") of Jacques-Louis David's official portrait of 1801, *Napoleon crossing the Great Saint Bernard Pass* (fig. 53).[61] The coronation festival's equestrian statue, which appeared, suddenly, *en transparent,* is a direct quotation from the portrait. Its rearing steed and Napoleon's billowing cloak both originate with David.[62] Not surprisingly, the portrait (where, in contrast to the machine, Bonaparte dominates while the Alps recede) took great liberties with reality. After all, the "hero" had actually crossed on the back of a mule, and the day had been clear and mild, as opposed to the sublime tempest David painted. Indeed, the portrait is the quintessence of sublimity: the setting, the weather, the wild-eyed stallion controlled by its self-possessed rider (who had demanded that he be depicted "calm on a fiery steed"). In the middle ground of David's painting the French troops trudge slowly up the alpine pass. In the foreground, inscribed on a rock beneath Bonaparte's steed, we read the conqueror's name, below which the name Hannibal appears. Hannibal crossing the Alps was, of course, another exemplar of the literary and pictorial sublime. Here, the subject is appropriated by the (future) emperor through his "agent," David. The components, then, of the famous portrait—the now canonical equestrian pose with swirling cape, the swarming soldiers, the alpine backdrop—cannot have been lost on at least some of the spectators of the *feu d'artifice.*

By this time (1804), the Alps, like Vesuvius, had long been standards of the natural sublime, from John Dennis's emotive "delightful Horrour" and "terrible joy" felt in the mountains' presence (1693), to Walpole's breathless "precipices, . . . torrents, wolves, rumblings, Salvator Rosa" (1739), summed up, finally, by Ann Radcliffe's turgid absurdities in *The Mysteries of Udolpho* (1794).[63] By the end of the century, Helen Maria Williams could write, effusively, of "that solemn, that majestic vision, the Alps! . . . I longed to . . . wander amidst those regions of mysterious sublimity. . . ."[64]

The French contribution to the appreciation of alpine sublimity, while

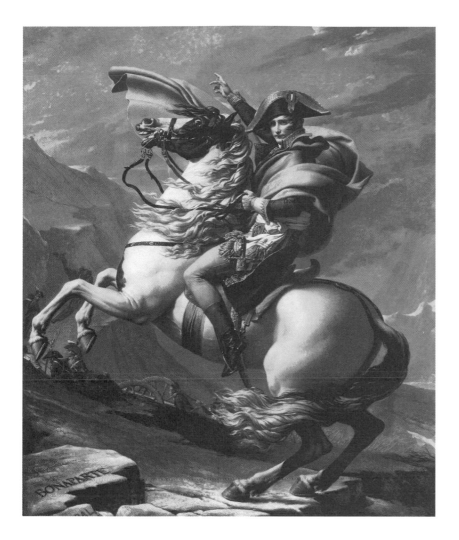

Fig. 53. Jacques-Louis David (1748–1825)
Napoleon crossing the Great Saint Bernard Pass
Oil on canvas. 102⅜ × 87 in (260.0 × 221.0 cm)
Château de Malmaison, Rueil-Malmaison
Lauros-Giraudon/Art Resource, NY

neither as consistent nor as dramatic as the English, comes, for example, via Rousseau's *La nouvelle Héloïse* of 1761 (in which the Alps function as a place "where one's meditations take on indescribable qualities of greatness and sublimity"[65]), climaxing with Saussure (*Voyages dans les Alpes,* 1779–1796), for whom "the tranquility and the deep silence ruling over this vast expanse, and further increased by my imagination, inspired in me a kind of terror."[66] As D. G. Charlton has observed, Saussure "feels and expresses, perhaps for the first time in French literature, a sense of the [Alps'] wild sublimity."[67]

The Alps thus serve, in the coronation *feu d'artifice,* as paradigmatic backdrop to the imperial sublime—natural sublimity merging with the sublimity of revolution, of conquest, of predestined empire. Our response is determined by the response of the internal spectators—hands raised in astonishment (as at the birth of the dauphin), gestures of awe, of wonder before the explosion of alpine pyrotechnics, the airborne crown, the shining equestrian monument, the imperial massiveness of it all. The fireworks, then, become a reflection of the grandiosity, the overweening ambition, of the emperor himself, all couched in the language of the sublime. This is both a culmination and a conclusion. The festival of the coronation unites two conventions of the natural sublime: the Alps and Vesuvius (the latter evoked particularly by the volcano-like eruption of fireworks), joined to the artificial sublime (David's portrait, the *feu d'artifice,* the memory of the Castel Sant'Angelo[68]) and framed by the ancient discourse of the four elements (earth—Mount Saint Bernard; water—the Seine; air—the balloon; fire—the fireworks). The old language of the festival cannot survive such a perfect fusion; in the wake of the imperial sublime, it must yield to something new.

Mimesis and the Sublime

A nagging question remains. While actual fireworks may be a manifestation of the (artificial) sublime, and while certain representations of those fireworks may intentionally direct the viewer to that conclusion, what of the actual representations themselves? Do they, indeed *can* they, independently evoke—like a Mount Vesuvius or a Castel Sant'Angelo—feelings of sublimity in the spectator? With Wright of Derby, of course, we may respond unequivocably in the affirmative. But the case of paintings, a more intrinsically mimetic medium, is considerably less problematic than that of prints. Only rarely do we encounter as interesting a response as that of Böttiger toward Kuntz's aquatint of the *Stein* at Wörlitz, where "the most magnificent aspect of the whole spectacle…is brought out particularly well." It is important to keep in mind Böttiger's postscript that "one cannot deny [Kuntz] the achievement… that it is drawn from nature, and yet it results in completely different expectations than the spectacle in nature does."[69] One would have thought this too obvious to belabor. As it is so clearly not the "spectacle in nature," how can it result in anything other than different expectations? And yet for Böttiger the distinction between the *Stein* and its source (Vesuvius) is not so clear. "To complete the contrast, one need only think of the colored pages of Hamilton's

Campi Phlegraei," he suggests, "or even of the engraving of the last eruption of Vesuvius in *Philosophical Transactions* and, in a reduced reproduction of the latter, in *European Magazine."*

Note that Böttiger does not ask his readers to contrast Kuntz's aquatint with Vesuvius itself in order to appreciate the different expectations of the spectacle in nature. He asks them, instead, to contemplate *illustrations* of Vesuvius erupting, particularly those in Hamilton's *Campi Phlegraei.*[70] As evocations of Vesuvius's power, it would be difficult to find images as successful as Pietro Fabris's hand-colored etchings for the *Campi Phlegraei.* They were from the first greatly admired adjuncts to Hamilton's text. In fact, they can be said to have been the efficient cause of the publication, the contents of which had appeared, unillustrated, twice before. Whether they provoked feelings of sublimity is difficult to say. Unlike the work of his contemporaries (artists like Volaire and Vernet, who consciously sought picturesque and sublime qualities in their Vesuvius paintings in order to appeal to the tourist market), Fabris strove, above all, for accuracy in these images under Hamilton's guidance and supervision. And yet, some of them cannot avoid the trappings of the sublime, as, for example, plate II in the *Supplement* (pl. 16) where Vesuvius, at night and in full eruption, is witnessed by four terrified spectators silhouetted against the reflected light of the volcano. One prostrates herself in fear or supplication; another, on her knees, extends toward the mountain a (painted?) image, apotropaic in intent, of either the Virgin or San Gennaro.

"The passion caused by the great and sublime in nature...is Astonishment; and astonishment is that state of the soul, in which all its motions are suspended, with some degree of horror," wrote Burke in the *Enquiry* (II.i). While it is safe to say that, in the etching, the internal witnesses to Vesuvius's rage experience only terror, without sublimity, we, the external spectators, safe in our distance from the actual event, are asked to indulge in "sympathy" for the hapless people of Naples, the principle, as defined by Burke, whereby "poetry, painting, and other affecting arts transfuse their passions from one breast to another" (I.xiii).

"An image," claims Burke, "is never so perfect, but we can perceive it as an imitation, and on that principle are somewhat pleased with it. And indeed in some cases we derive as much or more pleasure from that source than from the thing itself...," (I.xv) and "when the object of the painting...is such as we should run to see if real..., we may rely upon it, that the power of the... picture is more owing to the nature of the thing itself than to the mere effect of imitation" (I.xvi). Burke's implication, then, is that some of the essence of the thing that is represented may, under the right conditions, be retained and transmitted through the representation of that (presumably sublime) thing. This may bring us closer to understanding Böttiger's remarks. Although impressed by Kuntz's success in bringing out the most magnificent aspect of the whole spectacle, as a representation of a representation the print nevertheless results in completely different (and hypothetically inferior) expectations than the real item. The same cannot be said about the illustrations from *Campi*

Phlegraei, which are no mere reflections of a reflection but drawn directly from their source and thus capable of giving "as much or more pleasure... than from the thing itself."

Something similar might be said about Louis Le Coeur's aquatint of the *feu d'artifice* for the coronation of Napoleon. "Sympathy" — with the attitudes of astonishment and awe and pleasure of the internal spectators, whom the artist has gone to some pains effectively to delineate — is meant to be our dominant response. Several among the audience, in fact, assume certain conventional gestural *topoi* from the taxonomy of the "passions" codified in seventeenth- and eighteenth-century art theory. Our "authentic" response is dictated by the image's "artificial" response (the response of the internal audience). Our "sympathy" functions, then, as a bridge to the (experience of) the sublime, so that, while we may be removed from the direct experience, we nevertheless share in it through the (imperfect) medium of the image. "The nearer [a representation] approaches the reality, and the further it removes us from all idea of fiction, the more perfect is its power. But be its power of what kind it will, it never approaches to what it represents," cautions Burke, both extolling and admonishing at the same time (I.xv).

Yet even with Böttiger, loftier impressions are mingled with the mundane. In the same note in which we find his remarks about Kuntz's aquatint, we are informed that the print is currently available and may be purchased for twelve thalers. Documentary prints are, by nature, commodities, and to a degree very different from paintings. The reviewer of the Royal Academy exhibition in which Wright of Derby's *Vesuvius* and *Girandola* appeared would not have informed his readers of the pictures' selling price.

For the English theorist-painter Joshua Reynolds "imitation does not mean reproduction," and "minute imitation... is inimical to the grand style."[71] Reynolds, like any other eighteenth-century academic aesthetician, English or French, would have paid scant attention to documentary prints (and then only in the form of reproductive engraving). They were certainly not included in contemporary discussions of the hierarchy of the arts because they were not, strictly speaking, art. Any attempt to discover intrinsic sublimity in these works is necessarily frustrated by this fact.

There remains one intriguing example. In William Hamilton's letter to the Royal Society of 29 December 1767, he enclosed, along with some sketches, a "transparent" painting which "when lighted up with lamps behind it, gives a much better idea of Vesuvius, than is possible to be given by any other sort of painting."[72] The President's reply to Hamilton is extremely revealing: "The representation of that grand and terrible scene, by means of transparent colours, was so lively and so striking, that there seemed to be nothing wanting in us distant spectators but the fright that everybody must have been fired with who was so near."[73]

Hamilton's transparent painting (an early form of "special effects") was a popular species of eighteenth-century optical entertainment. As in this instance, these "amusements" sometimes embraced a serious, educative,

purpose. What is notable is that an audience as highly sophisticated as the members of the Royal Society should be so moved by this object—not a painting, not a drawing, not a print, but something in the interstices, not fitting comfortably into any traditional category of art. Fright was wanting, of course—so the pure Burkean sublime contracts. But the work comes very close to inducing a response we have come to expect only from nature or, occasionally, from the paintings of Wright of Derby (or, later, J. M. W. Turner). The categories, like the conventions, are not so fixed. Like Hamilton's "transparent colours" they are, perforce, constantly shifting, sensitive to the direction and intensity of the source of illumination.

Playing with Fire

Optical devices as a form of domestic entertainment, in the seventeenth, eighteenth, and nineteenth centuries, often granted access to the inaccessible (the Chinese imperial court, for example, or a natural disaster like the Lisbon earthquake of 1755), or, as in the case of fireworks, to the transient and ephemeral. A home theater such as a peep show amazed its audience by its clever use of light and transformative effects. At the same time it rendered the extraordinary ordinary through miniaturization and through the capacity for endless repetition. Unlike an *actual* fireworks display or the *real* Lisbon earthquake, the experience of these optical reconstructions was repeatable to the point of ennui, thus inevitably reducing the terrible or the magnificent (in the Burkean sense) to the merely curious.

The *vue d'optique* illustrating a fireworks spectacle (real or fictional is uncertain) in honor of Emperor Joseph II (ruled 1765–1790) works its magic through metamorphosis (pls. 17, 18). With the print properly inserted into a slot at the back of the *guckkasten* ("peep show"; pl. 19), light may be projected from a source in front or behind. With front-projected light, the entire scene is clearly illuminated. With back-projected light, however (and anterior light removed), the fireworks and illuminations assume autonomy. Only the dozens of perforations in the *vue d'optique* (backed with transparent yellow and red paper) are visible now (see pl. 18). Without knowledge of its first state, the image's second state is meaningless, an abstract pattern of static dots.

The eighteenth-century glass fireworks theater from the Theater Instituut Nederland (pl. 20) impresses not through sudden metamorphosis, as with the Joseph II print, but through multiple layering, an additive rather than a transformative process. An extraordinary range of color and light effects is achieved through the theater's five painted panels placed one in front of the other, creating, at the same time, the illusion of great depth. While the effect of the glass theater is certainly more dazzling than the *guckkasten,* its structure is essentially the same. With the nineteenth-century optical device called *Voyage où il vous plaira* ("Travels where you please"; pl. 23), we return to the transformative quality of the Joseph II *vue d'optique,* but here the impact is far more dramatic. Though much smaller than the *guckkasten,* the principle of the *Voyage* is similar, in that a card or "slide" is inserted at one end of the

97

device, and light admitted either from the front or back. In the *vue d'optique*, though, much of the image was lost in the process of alteration. In the more sophisticated *Voyage,* one complete view (of scattered clusters of afternoon tourists at Versailles) is miraculously transformed, also by the displacement of light, into another complete view—a surging crowd witnessing a brilliant nocturnal explosion of colored rockets (pls. 21, 22). This autonomous second image is literally concealed beneath the first, sandwiched between the protective mounts of the "slide."

Unlike Hamilton's transparent painting, these theaters did not harbor an educative purpose, or did so only at a very rudimentary level. Their principal function was to astound (while amusing) the viewer, and, to the extent that this was realized, something of the sublime seeps into their reception. The distance from the real, terror-inducing spectacle is too great, the process of domestication too complete, of course, to elicit the true sublime, and yet, as early forms of "special effects," we know that these devices were highly successful and that their audiences were impressed. In a sense, lacking the edifying function of Hamilton's painting, these recreational theaters engendered a kind of pure emotive response, and thus may have come closer to arousing sublime feelings for the average viewer, however diluted, than even Hamilton's *Vesuvius* did for the members of the Royal Society.

The desire to domesticate fireworks may seem unusual, and yet it has a long history. At least by the early seventeenth century, recipes for household fireworks (usually as a form of practical joke) can be found in some recreational treatises. But mechanically advanced paper firework devices survive as well, and techniques for constructing them are described in Hooper's *Rational Recreations,* itself drawing on much older traditions and practices. While these optical toys may appear to be an entirely different class of material than the "documentary" images that make up the majority of *Incendiary Art*, from time to time (as with the Joseph II *vue d'optique*) the mimetic and the mnemonic intersect. The same may be said about documentary records where truth and fiction so often overlap, where, in fact, the imitative (the attempt to capture the fugitive nature of fireworks) and the commemorative collide. This collision, finally, lies at the center of *Incendiary Art,* which has attempted to operate in the tense space between these two tropes.

One of the declared intentions of this exhibition has been to demonstrate that pyrotechnics in early modern Europe conveyed meaning, and that the many representations produced over a period of three centuries, if properly interpreted, allow us partial access to that meaning. But meaning, like fireworks, can be elusive, shifting like the fabric of Pythagoras's universe. We are left, in the end, with the images themselves, ironically static emblems of the perpetually disintegrating. It is hoped that, at the very least, *Incendiary Art* bears sufficient witness to their enduring power, their beauty, and their intrinsic interest.

Notes

Unless otherwise indicated, all translations are my own, with the assistance of Steven Lindberg (German), Isotta Poggi (Italian), and Leslie Walker (French).

1. As especially fine examples of this intersection, see two unpublished manuscripts in Getty Research Institute collections: John Maskall's "Artificial Fireworks," 3 vols. (London, 1785; pl. 1), which describes the production of recreative fireworks but does so in a military milieu—its dedication to Major Congreve, Commandant of the Royal Laboratory at Woolwich—and a Dutch manuscript from the second half of the eighteenth century ("Beschrijving van kunst vuurwerken") whose beautifully rendered colored designs draw on a long tradition of military-recreational fireworks treatises (pl. 2). See also discussion below, "Homo Pugnans."

2. Quoted and translated in Orest Ranum, "Islands and the Self in a Ludovician Fête." In David Lee Rubin, ed., *Sun King: The Ascendancy of French Culture during the Reign of Louis XIV* (Washington: Folger Shakespeare Library, 1992), 30.

3. The engraving was originally issued in two sections, the left considerably narrower than the right. The Getty example is, unfortunately, missing the left section.

4. Jean de La Fontaine, *Œuvres de Jean de La Fontaine,* ed. Henri Regnier (Paris: Hachette & Cie, 1883–97), 9:351.

5. Luigi Manzini, *Applausi festivi fatti in Roma per l'elezzione di Ferdinando III* (Rome: Pietro Antonio Facciotti, 1637), 36.

6. Amédée-François Frézier, *Traité des feux d'artifice pour le spectacle* (Paris: Jombert, 1747), 394.

7. Denis-Pierre-Jean Papillon de La Ferté, *Journal de Papillon de La Ferté, intendant et controlleur de l'argenterie, menus-plaisirs et affaires de la chambre du roi, 1756–1780,* ed. Ernest Boysse (Paris: P. Ollendorff, 1887), 123 (23 June 1763). Among other responsibilities, the superintendent of the "Menus-plaisirs" managed all court spectacles, ordinary and extraordinary, including royal funerals, marriages, and celebrations of "public rejoicing."

8. See Horace Walpole, *Horace Walpole's Correspondence with Madame du Deffand*, vol. 4, no. 2, ed. W. S. Lewis and Warren Huntington Smith (New Haven: Yale Univ. Press, 1939), 411 (du Deffand to Walpole, 19 May 1770); see also Papillon de La Ferté (note 7), 275–76 (20 May 1770).

9. Quoted in Alain-Charles Gruber, *Les grandes fêtes et leurs décors à l'époque de Louis XIV* (Geneva: Droz, 1972), 122. See below, "The Political Sublime," and plate 14 and figure 52.

10. Papillon de La Ferté (see note 7), 248 (30 April 1769).

11. Papillon de La Ferté (see note 7), 281 (28 July 1770).

12. Horace Walpole, *Horace Walpole's Correspondence with Sir Horace Mann,* vol. 20, no. 4, ed. W. S. Lewis, Warren Huntington Smith, and George L. Lam (New Haven: Yale Univ. Press, 1937), 47–48 (Walpole to Mann, 3 May 1749).

13. André Félibien, *Relation de la feste de Versailles* (Paris: Le Petit, 1668), 60.

14. Giovanni Andrea Moniglia, *Ercole in Tebe* (Florence, 1661), 152.

15. Jean-Louis de Cahuzac, "Feux d'artifice" in Denis Diderot, *Encyclopédie* (Paris: Briasson, 1751–72; reprint, Stuttgart-Bad Cannstatt: Frommann, 1966), 6

(1756): 639–40. Amédée-François Frézier offered the same advice: "A spectacle that is no more than a burning woodpile, accompanied by a few confusedly thrown rockets that leave only useless smoke in the air, is unworthy of the public." Frézier (see note 6), 383–84. This sounds suspiciously like a passage from *Les réjouissances de la paix:* "Fireworks machines should never be simple woodpiles where one sees only stacked bundles of sticks placed without design, and a lot of rockets that leave only some smoke after having made a little noise. The mounting must be ingenious and the mind should be as satisfied as the eye" (Lyons: Benoist Coral, 1660), 6.

16. It should be noted that Cahuzac plagiarized his description of the fete from the account published in the *Mercure de France* (February, 1730): 390–403. See also the pamphlet *Description de la feste et du feu d'artifice, qui doit être tiré sur la riviere, au sujet de la naissance de monseigneur le dauphin...le 24. Janvier 1730* (Paris: La Veuve Mergé, 1730).

17. *Mercure* (see note 16): 391.

18. *Mercure* (see note 16): 400.

19. By "distributional hierarchy" I mean that prints on satin, when presented as diplomatic gifts, were reserved for a select few—popes and monarchs, for example. All other recipients received impressions on paper, although often the privileged beneficiary of a satin impression also received a duplicate on paper—a fact that accentuates the nonutilitarian nature of the former.

20. See especially Govard Bidloo's *Relation du voyage de sa majesté britannique en Hollande* with its meticulous analysis of the fireworks theater and its allegorical significance, and the beautifully described effects of the fireworks themselves which, finding that they could not penetrate the ice-covered water of the Vyver, scudded along the surface, their shimmering reflections "on this vast mirror" seeming "to restore to the water its liquid and transparent form" (The Hague: A. Leers, 1692), 71–72.

21. For a discussion of both the Girandola and the "Festival of the Chinea," see below, "Fireworks and the Sublime."

22. We find a similar moralizing in Pierre Le Moyne's *Devises héroïques et morales,* where, beside the emblem of a sputtering rocket, the author explained: "There is a fatal blaze that draws all eyes to itself and does evil to all eyes so drawn. This blaze is Wealth, which Injustice and Fortune have made in haste.... They mount to the highest region of the great world. They make the stars jealous by their din and efface their luster. They make public spectacles of their private pomp and magnificence. And this pomp is the blood and substance of their dying country" (Paris: Augustin Courbé, 1649), 110–11.

23. Cahuzac (see note 15), 639.

24. Edmund Burke, *A Philosophical Enquiry into the Origin of Our Ideas of the Sublime and Beautiful,* ed. Adam Phillips (Oxford: Oxford Univ. Press, 1990; originally published London: R. and J. Dodsley, 1757), Part I, Section vii. Hereafter cited in the text by part and section numbers.

25. It is impossible, in the space allowed, to address those of Burke's categories—such as "Light," "Infinity," "Suddenness," "Sounds and Loudness"—that are indirectly relevant to the subject of fireworks. Nor does space permit a discussion of the French sublime. As Christopher Thacker describes the situation in *The Wildness*

Pleases: The Origins of Romanticism: "The years from 1755 until 1760 are the *anni mirabiles* of this subject, with a flood of writings coming so close together that it is often impossible to say which author influenced which at what point. What is certain is that Burke, Young and Gray in England, and Diderot and Rousseau in France, were all considering the sublime...and that their interest was often communicated to friends before the actual publication of their writings. In 1757...the second edition of Burke's treatise...appears,...Diderot's *Entretiens sur le fils naturel* appears, followed by the [*Encyclopédie*] article 'Génie' ['Genius'], and in the background Rousseau is deep in the composition of the *Nouvelle Héloïse.*" (New York: St. Martin's Press, 1983), 83. See also D. G. Charlton, *New Images of the Natural in France: A Study in European Cultural History, 1750–1800* (Cambridge: Cambridge Univ. Press, 1984), 41–65.

26. La Fontaine (see note 4), 9:350.

27. *Feste di fuochi distinte in tre pompose macchine fatte alzare sulla piazza esteriore della fortezza di Parma* (Parma: Stampería de S.A.S, 1724), 57.

28. Quoted in Judy Egerton, ed., *Wright of Derby* (London: Tate Gallery, 1990), 172, 175.

29. Quoted in Filippo Clementi, *Il carnevale romano: Nelle cronache contemporanee,* 2 vols. (Città di Castello: Edizioni R.O.R.E.-Niruf, 1938–39), 1:568, illustrated on page 79.

30. Manzini (see note 5), 42.

31. Ovid, *Metamorphoses,* trans. Rolfe Humphries (Bloomington: Indiana Univ. Press, 1955), 375.

32. The *macchina* served as the decorative base for the spectacle. It was an important practical and aesthetic component of the event and was often architecturally inventive.

33. See, for example, Sir William Hamilton's *Campi Phlegraei: Observations on the Volcanoes of the Two Sicilies* (Naples: n.p., 1776), plate XXXVIII (pl. 8): "A night view of the current of lava, that ran from Mount Vesuvius towards Resina, the 11th of May 1771. When the author had the honor of conducting THEIR SICILIAN MAJESTIES to see that curious phenomenon, a beautiful cascade of fire of more than 50 feet... [which] produced the finest effect that can possibly be imagined." In this remarkable illustration, the king and queen, in formal attire, accompanied by a handful of courtiers and soldiers, observe the lava flow like spectators at the theater or at a public festival. Within a few feet of the fiery precipice, Hamilton discourses as if revealing the subtleties of a particularly recondite allegory.

34. Hamilton (see note 33), 17 (italics mine).

35. William Hamilton, *Supplement to the Campi Phlegraei* (Naples: n.p., 1779), 5 (italics mine).

36. *Voyage en Italie, en Sicile et à Malte—1778* ([Belgium]: Martial, [1994]), 1:188–89 (italics mine). The musicologist Dr. Charles Burney, visiting Hamilton in 1770, wrote of Vesuvius that "[t]he sight was awful and magnificent, resembling on a great scale the most ingenious and splendid fireworks I ever saw." Quoted in Carlo Knight, "William Hamilton and the 'art of going through life'" in Ian Jenkins and Kim Sloan, *Vases and Volcanoes: Sir William Hamilton and His Collection* (London: British Museum Press, 1996), 15.

37. Nicholas Boyle, *Goethe: The Poet and the Age* (Oxford: Oxford Univ. Press, 1992), 301.

38. Thacker (see note 25), 184.

39. Karl August Böttiger, *Reise nach Wörlitz 1797,* ed. Erhard Hirsch, 2nd ed. (Wörlitz: Staatliche Schlösser und Gärten, Wörlitz, Oranienbaum und Luisium, 1973), 79–81.

40. Böttiger (see note 39), 81.

41. Quoted and translated in Thacker (see note 25), 186–87. There is some question as to the authorship of this passage. See Basil Guy, trans. and ed., *Coup d'Oeil at Beloeil and a Great Number of European Gardens* (Berkeley and Los Angeles: Univ. of California Press, 1991), 261.

42. William Hooper, *Rational Recreations,* 3rd ed., 4 vols. (London, 1787), 4:155–56.

43. Cited in Gaetano Moroni, comp., *Dizionario di erudizione storico-ecclesiastica* (Venice: Tipografia Emiliana, 1840–61), 10:197.

44. Charlotte Eaton, *Rome in the Nineteenth Century,* 5th ed. (London: n.p., 1852; first edition published 1820), 209.

45. Moroni (see note 43), 10:197.

46. In July, 1787, Desprez and Piranesi issued a prospectus announcing their intention to produce a series of Italian views in a technique they called *dessins coloriés* ("colored drawings"). While the technique was simply etching (by Piranesi), with watercolor and gouache applied by hand (by Desprez), the ambiguity was probably intentional, the purpose being to attract a monied audience of tourists unable to distinguish a print from an original drawing. The prospectus listed a total of forty-eight anticipated views, of which five were Roman. Only ten of these were ever produced. Of the Roman views, three were completed.

47. Quoted in J. Fleming, *Robert Adam and His Circle in Edinburgh and Rome,* 3rd printing (London: John Murray, 1978), 177.

48. Vannoccio Biringuccio, *De la pirotechnia* (Venice: Venturino Roffinello, 1540), 166. Quoted in Cyril Stanley Smith and Martha Teach Gnudi, *The Pirotechnia of Vannoccio Biringuccio* (New York: The American Institute of Mining and Metallurgical Engineers, 1943), 443.

49. G. Gualdo Priorato, *The History of the Sacred and Royal Majesty of Christina...* (London, 1658). Quoted in Per Bjurström, *Feast and Theatre in Queen Christina's Rome* (Stockholm, 1966), 28–30.

50. Gasparo Alveri, *Della Roma in ogni stato* (Rome, 1664), 2:113. The same metaphor is used in 1724 in the published program of the "Feste di fuochi," held in Parma in honor of Pope Benedict XIII: "like a swarm of bees disturbed from its sweet repose" (*Feste di fuochi distinte in tre pompose macchine...* [Parma: Stampería de S.A.S., 1724], 58).

51. Even Biringuccio, in 1540, commented on the fact that the Castello was itself the fireworks *macchina,* in other words, a fixed and permanent machine, not ephemeral at all: "instead of constructing this edifice they make use of the whole castle, which is indeed a very pleasant shape."

52. Eaton (see note 44), 209–10.

53. Johann Wolfgang von Goethe, *Italian Journey (1786–1788),* trans. W. H. Auden and Elizabeth Mayer (San Francisco: North Point Press, 1982), 344.

54. Johann Wolfgang von Goethe, *Elective Affinities (Goethe's Collected Works,* vol. 11), trans. Victor Lange and Judith Ryan (New York: Suhrkamp, 1988), 159. Translation modified slightly.

55. Goethe, *Italian Journey* (see note 53), 324–25.

56. What exists only by implication in *The Elective Affinities* — fireworks as a metaphor for sexual climax (and, more broadly, for social disintegration) — will require another century to be made explicit by James Joyce, in the Gertie Macdowell episode of *Ulysses:* "She would fain have cried to him chokingly, held out her snowy slender arms to him to come.... And then a rocket sprang and bang shot blind blank and O! then the Roman candle burst and it was like a sigh of O! and everyone cried O! O! in raptures and it gushed out of it a stream of rain gold hair threads and they shed and ah! they were all greeny dewy stars falling with golden, O so lovely, O, soft, sweet, soft!" (James Joyce, *Ulysses* [New York: Vintage Books, 1986], 300).

57. *Von Himmeln entzindete und durch allgemainen Zuruff der Erde sich himmelwerts erschwingende Frolokhungs Flammen* (Vienna: n.p., 1666).

58. Quoted in Gruber (see note 9), 118.

59. The Getty impression is the first state of three — pure etching before the addition of engraving. As a result, the fireworks appear unfinished, as indeed they are.

60. Helen Maria Williams, *Letters Written in France* (1790). In Andrew Ashfield and Peter de Bolla, eds., *The Sublime: A Reader in British Eighteenth-Century Aesthetic Theory* (Cambridge: Cambridge Univ. Press, 1996), 300.

61. From 1792 until his arrest in 1794, David organized and designed some of the most important revolutionary fetes (e.g., "The Festival of the Supreme Being," 8 June 1794). He had some similar responsibilities under Napoleon (e.g., supplying designs for the coronation festivities), although there is no evidence that he had a hand in the coronation *feu d'artifice.*

62. The addition of Pegasus's wings to the coronation monument horse grants Napoleon mythological status (at the same time placing him in mythical rather than historical time), as he is here equated with Bellerophon, Pegasus-tamer.

63. Samuel Holt Monk, *The Sublime: A Study of Critical Theories in Eighteenth-Century England* (Ann Arbor: Univ. of Michigan Press, 1960), 207, 211, 220.

64. Helen Maria Williams, *A Tour in Switzerland* (1798), chapter IV. In Ashfield and de Bolla (see note 60), 303.

65. Charlton (see note 25), 47–48.

66. Quoted and translated in Charlton (see note 25), 49.

67. Charlton (see note 25), 49.

68. That memory was active in Paris at least as early as 1778, when, for the fete held on the Pont Neuf for the birth of Madame Royale, a copy of the Castel Sant'Angelo was constructed as the fireworks machine, from which a spectacular *girandola* erupted. See Gruber (note 9), 105, and figure 64.

69. Böttiger (see note 39), 81.

70. No more than a handful of his readers could have been acquainted with a publication as rare and costly as the *Campi Phlegraei.* Indeed, it might be expected

that as many had seen Vesuvius itself erupting. "Although *Campi Phlegraei* is Hamilton's chief monument today, it remains an expensive rarity, and little known except to vulcanologists during his own day" (G. Thackray, "'The Modern Pliny': William Hamilton and Vesuvius," in Jenkins and Sloan (see note 36), 70.

71. Quoted in Monk (see note 63), 184.

72. Quoted in Thackray (see note 70), 66–67.

73. Thackray (see note 70), 67.

Selected Bibliography

Primary Sources

Alveri, Gasparo. *Della Roma in ogni stato*. 2 vols. Rome: Mascardi, 1664.

Appier Hanzelet, Jean. *La pyrotechnie de Hanzelet de Lorrain, ou sont representez les plus rares & plus appreuvez secrets des machines & des feux artificiels, propres pour assieger battre surprende & deffendre toutes places*. Pont-à-Mousson: Gaspard Bernard, 1630.

Babington, John. *Pyrotechnia: or, A Discourse of Artificiall Fire-works*. London, 1635.

Beke, Guillaume van der. *Serenissimi principis Ferdinandi Hispaniarum infantis S. R. E. cardinalis triumphalis introitus in Flandriae metropolim Gandauum*. Antwerp: Ex officinâ Joannis Meursi, 1636.

"Beschrijving van kunst vuurwerken zoo als dezelven zich in hunne uitwerkingen vertoonen." Manuscript, Dutch, second half of eighteenth century. Getty Research Institute for the History of Art and the Humanities, Special Collections, acc. no. 970037.

Bidloo, Govard. *Relation du voyage de sa majesté britannique en Hollande*. The Hague: A. Leers, 1692. Originally published as *Komste van zyne majesteit Willem III., konig van Groot Britanje, enz. in Holland*. The Hague: A. Leers, 1691.

Biringuccio, Vannoccio. *The Pirotechnia of Vannoccio Biringuccio*. Translated by Cyril Stanley Smith and Martha Teach Gnudi. New York: The American Institute of Mining and Metallurgical Engineers, 1943. Originally published as *De la pirotechnia. Libri X*. Venice, 1540.

Bochius, Joannes. *Descriptio publicae gratulationis, spectaculorum et ludorum in adventu sereniss. principis Ernesti archiducis Austriae*. Antwerp: Plantin, 1595.

Boscoli, Giovanni Simone. *Applausi festivi fatti in Piacenza per la nascita della maestà del reale infante Filippo Prospero della Spagna*. Parma: Erasmo Viotti, 1658.

Böttiger, Karl August. *Reise nach Wörlitz 1797*. Edited by Erhard Hirsch. 2nd ed. Wörlitz: Staatliche Schlösser und Gärten, Wörlitz, Oranienbaum und Luisium, 1973.

Burke, Edmund. *A Philosophical Enquiry into the Origin of Our Ideas of the Sublime and Beautiful*. Oxford: Oxford Univ. Press, 1990. Originally published London, 1757.

Description de la feste et du feu d'artifice qui doit être tiré sur la riviere, au sujet de la naissance de monseigneur le dauphin…24 janvier 1730. Paris: La Veuve Mergé, 1730.

Description des festes données par la ville de Paris, à l'occasion du mariage de Madame Louise-Elisabeth de France, & de Dom Philippe, infant & grand amiral d'Espagne. Paris: P. G. Le Mercier, 1740.

Diderot, Denis. *Encyclopédie; ou, dictionnaire raisonné des sciences, des arts et des métiers.* Paris: Briasson, 1751–65.

Eaton, Charlotte Anne. *Rome in the Nineteenth Century.* 5th ed. 2 vols. London: H. G. Bohn, 1852. Originally published Edinburgh, 1820.

[Félibien, André]. *Les divertissemens de Versailles donnez par le roy à toute sa cour.* Paris: Imprimerie royale, 1676.

———. *Les plaisirs de l'isle enchantée.* Paris: Imprimerie royale, 1674.

———. *Relation de la feste de Versailles du dix-huitième juillet mil six cens soixante-huit.* Paris: Pierre Le Petit, 1668.

Feste di fuochi distinte in tre pompose macchine fatte alzare sulla piazza esteriore della fortezza di Parma. Parma: Stampería de S.A.S., 1724.

"Fireworks Displays in Eighteenth-Century Russia: A Collection of Engravings." Saint Petersburg: n.p., 1740–96. Bound album of sixty-nine engravings, one watercolor, one ink drawing and thirteen pen-and-wash drawings. Getty Research Institute for the History of Art and the Humanities, Special Collections, ID no. 92-F291.

Frézier, Amédée François. *Traité des feux d'artifice pour le spectacle.* Paris: Jombert, 1747.

Furttenbach, Joseph. *Halinitro-pyrobolia: Beschreibung einer newen Büchsenmeisterey.* Ulm: Jonam Saurn, 1627.

Goethe, Johann Wolfgang von. *Elective Affinities.* Translated by Victor Lange and Judith Ryan. Vol. 11 of *Goethe's Collected Works.* New York: Suhrkamp Publishers, 1988.

———. *Italian Journey: 1786–1788.* Translated by W. H. Auden and Elizabeth Mayer. San Francisco: North Point Press, 1982.

Graminaeus, Theodor. *Beschreibung derer Fürstlicher Güligscher &c.: Hochzeit, so im jahr Christi tausent fünffhundert achtzig fünff… zu Düsseldorff.* Cologne, 1587.

Hamilton, William. *Campi Phlegraei: Observations on the Volcanoes of the Two Sicilies as They Have Been Communicated to the Royal Society of London.* Naples: n.p., 1776.

———. *Supplement to the Campi Phlegraei: Being an Account of the Great Eruption of Mount Vesuvius in the Month of August 1779.* Naples: n.p., 1779.

Hooper, William. *Rational Recreations.* 3rd ed. 4 vols. London, 1787.

Küchler, Balthasar. *Repraesentatio der fürstlichen Auffzug und Ritterspil.* Schwäbisch-Gmünd, 1611.

Manzini, Luigi. *Applausi festivi fatti in Roma per l'elezzione di Ferdinando III.* Rome: Pietro Antonio Facciotti, 1637.

Maskall, John. "Artificial Fireworks." Manuscript. 3 vols. London, 1785. Getty Research Institute for the History of Art and the Humanities, Special Collections, acc. no. 920091.

Moroni, Gactano, comp. *Dizionario di erudizione storico ecclesiastica da S. Pietro sino ai nostri giorni.* Venice: Tipografia Emiliana, 1840–61.

Papillon de La Ferté, Denis-Pierre-Jean. *Journal de Papillon de La Ferté....* Introduction by Ernest Boysse. Paris: P. Ollendorf, 1887.

Les rejouissances de la paix, avec un recueil de diverses pieces sur ce sujet. Lyons: Benoist Coral, 1660.

Relation de l'inauguration solemnelle de sa sacrée majesté imperiale et catholique, Charles VI. empereur des romains...: Celebrée à Gand ville capitale des la province, le XVIII. octobre 1717. Ghent: Augustin Graet, 1719.

Rode, August von. *Beschreibung des fürstlichen Anhalt-Dessauischen Landhauses und englischen Gartens zu Wörlitz.* Dessau: Heinrich Tänzer, 1814. Originally published Dessau, 1798.

Le soleil au signe du Lyon: D'ou quelques paralleles sont tirez, avec le tres-chrestien, tres-juste, & tres-victorieux monarque Louis XIII.... Lyons: Jean Jullieron, 1623.

Von Himmeln entzindete und durch allgemainen Zuruff der Erde sich himmelwerts erschwingende Frolokhungs Flammen. Vienna, 1666.

Walpole, Horace. *Horace Walpole's Correspondence with Madame du Deffand.* Edited by W. S. Lewis and Warren Hunting Smith. Vol. 4, no. 2. New Haven: Yale Univ. Press, 1939.

———. *Horace Walpole's Correspondence with Sir Horace Mann.* Edited by W. S. Lewis, Warren Hunting Smith, and George L. Lam. Vol. 20, no. 4. New Haven: Yale Univ. Press, 1960.

Weis, Johann Martin. *Représentation des fêtes données par la ville de Strasbourg pour la convalescence du roi.* Paris: Laurent Aubert, 1745.

Secondary Sources

Apostolidès, Jean-Marie. *Le roi-machine: Spectacle et politique au temps de Louis XIV.* Paris: Editions de Minuit, 1981.

Ashfield, Andrew, and Peter de Bolla, eds. *The Sublime: A Reader in British Eighteenth-Century Aesthetic Theory.* Cambridge: Cambridge Univ. Press, 1996.

Bjurström, Per. *Feast and Theatre in Queen Christina's Rome.* Stockholm, 1966.

Bracco, Patrick. *Fireworks/Feux d'artifices: French Fireworks from the Seventeenth to the Nineteenth Century,* exh. cat. Washington D.C.: International Exhibitions Foundation, 1976.

Brock, Alan St. Hill. *A History of Fireworks.* London: Harrap, 1949.

Chabrowe, Barbara. "Baroque Temporary Structures Built for the Austrian Habsburgs." Ph.D. diss., Columbia Univ., 1970.

Charlton, Donald Geoffrey. *New Images of the Natural in France: A Study in European Cultural History, 1750–1800.* Cambridge: Cambridge Univ. Press, 1984.

Chartier, Roger. "From Court Festivity to City Spectators." In *Forms and Meanings: Texts, Performances, and Audiences from Codex to Computer.* Philadelphia: Univ. of Pennsylvania Press, 1995.

Clementi, Filippo. *Il carnevale romano nelle cronache contemporanee.* 2 vols. Città di Castello: Edizioni R.O.R.E.–Niruf, 1938–39.

Di Lorenzo, Claudio. *Il teatro del fuoco: Storie, vicende e architettura della pirotecnica.* Padua: F. Muzzio, 1990.

Egerton, Judy. *Wright of Derby,* exh. cat. London: Tate Gallery Publishing, 1990.

Elias, Norbert. *The Court Society.* Translated by Edmund Jephcott. New York: Pantheon, 1983.

Fagiolo dell'Arco, Maurizio, and Silvia Carandini. *L'effimero barocco: Strutture della festa nella Roma del '600.* Rome: Bulzoni, 1977.

Fähler, Eberhard. *Feuerwerke des Barock: Studien zum öffentlichen Fest und seiner literarischen Deutung vom 16. bis 18. Jahrhundert.* Stuttgart: Metzler, 1974.

Fetes, Fireworks, and Other Festivities, exh. cat. New York: Metropolitan Museum of Art, 1971.

Fleming, John. *Robert Adam and His Circle in Edinburgh and Rome.* London: John Murray, 1978.

Gori Sassoli, Mario. *Della Chinea e di altre "macchine di gioa": Apparati architettonici per fuochi d'artificio a Roma nel settecento,* exh. cat. Milan: Charta, 1994.

Gruber, Alain-Charles. *Les grandes fêtes et leurs décors à l'époque de Louis XVI.* Geneva: Droz, 1972.

Jenkins, Ian, and Kim Sloan. *Vases and Volcanoes: Sir William Hamilton and His Collection,* exh. cat. London: British Museum Press, 1996.

Kohler, Georg, ed. *Die Schöne Kunst der Verschwendung: Fest und Feuerwerk in der europäischen Geschichte.* Zurich: Artemis, 1988.

Lotz, Arthur. *Das Feuerwerk: Seine Geschichte und Bibliographie.* Zurich: Olms, 1978.

Monk, Samuel Holt. *The Sublime: A Study of Critical Theories in Eighteenth-Century England.* Ann Arbor: Univ. of Michigan Press, 1960.

Moore, John E. "Prints, Salami, and Cheese: Savoring the Roman Festival of the Chinea." *Art Bulletin* 77, no. 4 (December 1995): 584ff.

Möseneder, Karl. "Feuerwerk." In *Reallexikon zur deutschen Kunstgeschichte,* vol. 8: 530ff. Munich: J. B. Metzler, 1987.

Mourey, Gabriel. *Le livre des fêtes françaises.* Paris: Le Librairie de France, 1930.

Oechslin, Werner, and Anja Buschow. *Festarchitektur: Der Architekt als Inszenierungskünstler.* Stuttgart: G. Hatje, 1984.

Philip, Chris. *A Bibliography of Firework Books.* Winchester: St. Paul's Bibliographies, 1985.

Rubin, David Lee, ed. *Sun King: The Ascendancy of French Culture during the Reign of Louis XIV.* Washington, D.C.: Folger Shakespeare Library, 1992.

Schaub, Owen. "Pleasure Fires: Fireworks in the Court Festivals in Italy, Germany, and Austria during the Baroque." Ph.D. diss., Kent State Univ., 1978.

Sergiacomi, Simonetta, ed. *"Fochi d'allegrezza" a Roma dal cinquecento all'ottocento,* exh. cat. Rome: Edizioni Quasar, 1982.

Sievernich, Gereon, and Hendrik Budde, eds. *Das Buch der Feuerwerkskunst: Farbenfeuer am Himmel Asiens und Europas.* Nördlingen: F. Greno, 1987.

Thacker, Christopher. *The Wildness Pleases: The Origins of Romanticism.* New York: St. Martin's Press, 1983.

Wilton, Andrew, and Ilaria Bignamini, eds. *The Grand Tour: The Lure of Italy in the Eighteenth Century,* exh. cat. London: Tate Gallery Publishing, 1996.

Incendiary Art:
The Representation of Fireworks in Early Modern Europe
Kevin Salatino

Kevin Salatino received his doctorate in art history from the University of Pennsylvania in 1992 with a dissertation entitled "The Frescoes of Fra Angelico for the Chapel of Pope Nicholas V: Art and Ideology in Renaissance Rome." He has taught in the art history departments of Middlebury College and the University of Pennsylvania. Dr. Salatino is currently Collections Curator, Graphic Arts, at the Getty Research Institute. In this capacity he has augmented the collections of prints and drawings with a special emphasis on architectural and ornamental prints and drawings and fifteenth- to nineteenth-century festival materials. His previous exhibitions include *Inventing Rome: Interpretations of an Urban Landscape* (Getty Research Institute, 1993). In addition to publishing and lecturing on topics in Renaissance art history, he has written on subjects ranging from fifteenth-century Rome to issues in contemporary art.

Bibliographies & Dossiers
The Collections of the Getty Research Institute
for the History of Art and the Humanities

In Print
Russian Modernism
Introduction by Jean-Louis Cohen
Compiled by David Woodruff and Ljiljana Grubišić
ISBN 0-89236-385-1

Irresistible Decay: Ruins Reclaimed
Michael S. Roth with Claire Lyons and
Charles Merewether
ISBN 0-89236-468-8

In Preparation
Maiolica in the Making: The Gentili Archive
Catherine Hess
ISBN 0-89236-500-5

Designed by Bruce Mau with Chris Rowat
Coordinated by Stacy Miyagawa
Type composed by Archetype in Sabon
Printed by Southern California Graphics on Cougar Opaque and Lustro Dull
Bound by Roswell Bookbinding

Bibliographies & Dossiers
Series designed by Bruce Mau Design Inc.